NAKED TRUTH

Approaches to the Body in Early-Twentieth-Century
German-Austrian Art

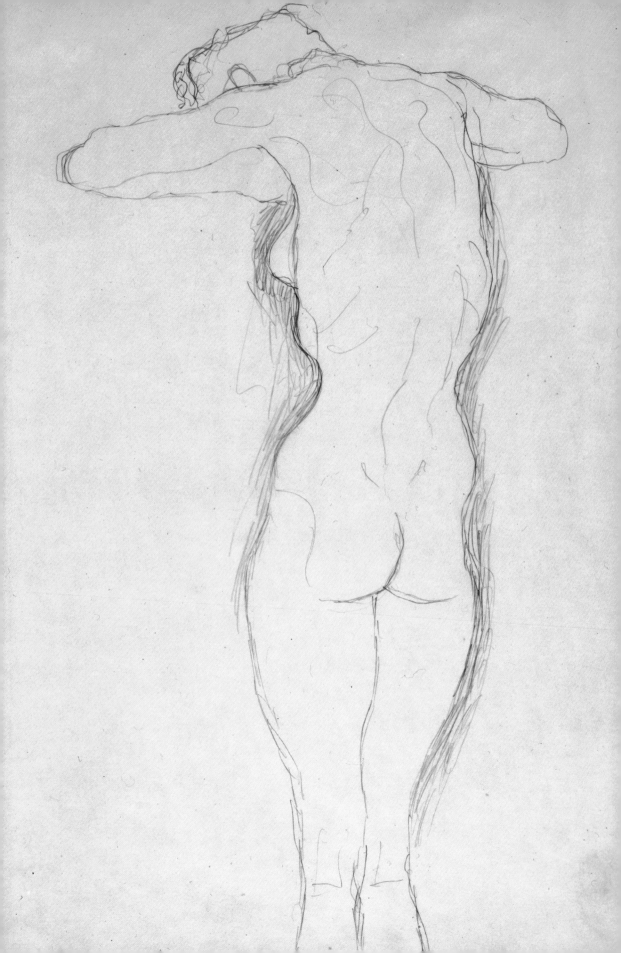

NAKED TRUTH

Approaches to the Body in Early-Twentieth-Century German-Austrian Art

Bettina Matthias

Eliza Garrison

James A. van Dyke

Introduction by
James A. van Dyke

MIDDLEBURY COLLEGE MUSEUM OF ART, VERMONT

DISTRIBUTED BY UNIVERSITY PRESS OF NEW ENGLAND

HANOVER AND LONDON

Naked Truth: Approaches to the Body in Early-Twentieth-Century German-Austrian Art, on view at the Middlebury College Museum of Art from September 11 through December 6, 2015.

The exhibition and catalogue were made possible by the Serge Sabarsky Foundation. Funding for the catalogue was also provided by a generous grant from the Middlebury College Arts Council.

Published by the Middlebury College Museum of Art
Distributed by University Press of New England
One Court Street, Lebanon, NH 03766
www.upne.com

LIBRARY OF CONGRESS CATALOGING-IN-PUBLICATION DATA

Naked truth (Middlebury College. Museum of Art)
 Naked truth : approaches to the body in early-twentieth-century
German-Austrian art / Bettina Matthias, Eliza Garrison, James A. van Dyke ;
with introduction by James A. van Dyke.
 pages cm
 "Naked Truth: Approaches to the Body in Early-Twentieth-Century
German-Austrian Art, on view at the Middlebury College Museum of Art from
September 11 through December 6, 2015."
 Includes bibliographical references.
 ISBN 978-1-928825-10-4
 1. Nude in art – Exhibitions. 2. Art, German – 20th century – Exhibitions.
3. Art, Austrian – 20th century – Exhibitions. 4. Sabarsky, Serge – Art
collections – Exhibitions. I. Matthias, Bettina. Body matters. II. Garrison,
Eliza. States of the body in the work of George Grosz and Otto Dix. III. Van
Dyke, James A. On the grotesque body in a double-sided drawing by Otto Dix.
IV. Middlebury College. Museum of Art. V. Title.
 N7572.N35 2015
 704.9'421–dc23 2015025564

Copyedited by Sheryl Conkelton
Designed by Christopher Kuntze
Printed by Puritan Capital, Hollis, NH

Photographic credits

Cover: Otto Dix, *Maud Arizona (Suleika, das tätowierte Wunder) (Maud Arizona [Suleika, The Tattooed Wonder])*, 1922. Etching on paper, 19⅝ × 16¹⁵⁄₁₆ inches. Sabarsky Foundation.

Page 2: Gustav Klimt, *Stehender weiblicher Rückenakt, die Arme horizontal gebeugt (Standing Female Nude, Back View, with Arms Horizontally Bent)*, 1917–18. Pencil on paper, 22⅜ × 14⅝ in. Sabarsky Foundation.

Page 48: Otto Dix, *Louis und Vohse (Louis and Vohse)*, 1923. Lithograph on paper, 25⁷⁄₁₆ × 19⅝ in. Sabarsky Foundation. © 2015 Artists Rights Society (ARS), New York/VG Bild-Kunst, Bonn.

Page 60: Otto Dix, *Schadow gewidmet. Sitzender weiblicher Akt (Dedicated to Schadow. Sitting Female Nude)*, 1923. Watercolor and pencil on paper, 22¹⁄₁₆ × 14⅞ in. Düsseldorf, Stiftung Museum Kunstpalast. Photo: Stiftung Kunstpalast–Horst Kolberg–ARTOTHEK. © 2015 Artists Rights Society (ARS), New York/VG Bild-Kunst, Bonn.

Back cover: Otto Mueller, *Zwei stehende Mädchen (Two Standing Girls)*, ca. 1928. Gouache and charcoal, 26⅛ × 19³⁄₁₆ in. Sabarsky Foundation.

Contents

Preface

In the spring of 2012 the Middlebury College Museum of Art was the recipient of an enormously generous gift from the Serge Sabarsky Foundation. This gift has enabled the Museum to bring Middlebury College students in direct contact with outstanding works of art by some of the most notable German and Austrian artists of the late-nineteenth and early-twentieth centuries. This exhibition is the outgrowth of a course (HARC/GRMN 0344 *Naked Truth: Approaches to the Body in Early-Twentieth-Century German-Austrian Art*) taught jointly at Middlebury last spring by Bettina Matthias, Professor of German, and Eliza Garrison, Associate Professor of History of Art and Architecture.

We are particularly grateful to the Foundation for enabling our faculty and students to have access to such a fascinating and important group of prints and drawings. It is an amazing opportunity and one given lasting value by the Middlebury College Arts Council, which has provided a generous subsidy to make this handsome and informative exhibition catalogue possible. It is collaborations such as this that give enhanced depth and meaning to the undergraduate experience at Middlebury and one that Serge Sabarsky (1912–1996), as a collector and art dealer, would undoubtedly have found immensely satisfying.

Richard Saunders
Director
Middlebury College Museum of Art
and Professor of History of Art and Architecture

Acknowledgments

Every exhibition is the result of collaborations of all kinds, and this is especially true for *Naked Truth: Approaches to the Body in Early-Twentieth-Century German-Austrian Art*. The story of this show is at the same time the story of a beautiful curricular and educational initiative of the Serge Sabarsky Foundation to support a sequence of exhibitions and courses involving their significant collection of early-twentieth-century German-Austrian art. Thanks to the vision and initiative of Richard Saunders, the director of the Middlebury College Museum of Art, Michael Lesh, the president of the Serge Sabarsky Foundation, entrusted Middlebury with both a generous grant and the chance to use works from the collection in our teaching. The first class to benefit from this initiative was a German class on Weimar Culture in the spring semester of 2014, and its final project was a student-curated exhibition, *Visual Weimar*, in which twenty-five works from the Weimar period went on display in the Museum's Overbrook Gallery in the fall of 2014.

While working on *Visual Weimar*, valuable support for our current exhibition was already being provided by Michael Gaffney, the 2013/14 Sabarsky Graduate Fellow, and Ellen Price, the Foundation's curator, who supported both projects simultaneously. By the time *Visual Weimar* closed, we were ready to tackle the "naked truth" of the second exhibition, which is significantly larger and more complex in scope. We are both extremely grateful to Peter Moore, this year's Sabarsky Graduate Fellow, for his guidance and help as we assembled this exhibit.

If *Visual Weimar* was the result of integrating original art into an existing cultural studies class, the *Naked Truth*—both the undergraduate seminar and the resulting exhibition—is the result of the kinds of meaningful educational innovation that Middlebury aims to support in its faculty. A collection of fifty works of art depicting a period's vastly diverse approaches to the human body, these images inspired the content and design of a completely new class. Interdisciplinary and team-taught by faculty from the Art History and German departments, the course followed an inductive approach to explore

questions of aesthetics, politics, ethics, biology, sociology, epistemology, and the relationship of these themes to the human body and its representations in the early decades of the twentieth century. Images guided our quest for overarching themes, and it was through our intensive work with the twenty students in this class that a rich narrative emerged. This included a retracing of the complex cultural sphere of body culture, fashion, gender, sexuality, class, and politics between 1880 and 1935; some of the results of these lines of questioning coalesced into the exhibition. Classes are only as successful as their participants, and we consider ourselves etxraordinarily fortunate to have had these twenty students in ours.

We are also deeply grateful for the intellectual and logistical support we received from many people. We are indebted to Prof. Karl Toepfer from San José State University for the invaluable insights he offered over email, in Skype discussions, and at his campus lecture in March 2015. Our colleague James A. van Dyke from the University of Missouri at Columbia not only lent his scholarly expertise by contributing his essay to this catalogue, but the synthesizing gaze of his introduction helped consolidate and provided context for many of the guiding themes of our exhibition. Our editor, Sheryl Conkelton, has honed our text. Ken Pohlman, the Museum's designer, and Jason Vrooman, the Museum's curator of education, offered valuable practical aid in our class's work on the exhibition's organization, layout, and thematic drive. Meg Wallace, Mikki Lane, and Doug Perkins were most helpful with all aspects regarding publicizing our exhibition and moving the catalogue along.

With gratitude,
Bettina Matthias
Eliza Garrison

Middlebury, Vermont
March 2015

NAKED TRUTH

Approaches to the Body in Early-Twentieth-Century
German-Austrian Art

Fig. 1. Gustav Klimt, *Zwei Studien einer an einem Tisch sitzenden jungen Frau, Wiederholung der rechten Schulterlinie* (*Two Studies of a Young Woman Seated at a Table, Repetition of the Right Shoulder*), 1885. Pencil with white heightening, 13¾ × 12⅜ in. Sabarsky Foundation.

A Sketch of Early-Twentieth-Century German and Austrian Prints and Drawings

James A. van Dyke

I N THE ART-HISTORICAL ORDER OF THINGS, the fifty works in *Naked Truth* belong to a single class of objects, namely, works on paper. That is what distinguishes them from other traditional categories such as painting, sculpture, architecture, and the decorative arts. In the collections of public museums, such things are found in *Kupferstichkabinetten* or *Grafische Sammlungen*, when one is in Germany and Austria, and in departments of prints and drawings in the English-speaking world. Because of the delicacy of their materials and the deleterious effects of light and humidity on paper, they are usually exhibited only rarely and sparingly. The rest of the time they are stored together in archival boxes and in climate-controlled vaults.

Such historical intellectual classifications and institutional compartmentalizations are necessary for the production of knowledge, the organization of thought, and the management of culture. Even a cursory glance at this selection of works on paper from the Sabarsky Foundation collection in New York, however, makes immediately evident the limited utility of such generic terminology. Though all were made by German-speaking artists, use paper as the support for an image, and render the human body (or some part of it), these prints and drawings are often very different formally and stylistically, materially and technically, ideologically and functionally. This essay will point to some of those differences in order to provide a sketch of the broad field that they constitute.

New Old Masters: Studying the Body

For centuries, drawing was regarded as the foundation of almost any artistic practice, the proof of the intellectual, form-giving, masculine powers of the artist. Color was secondary, often regarded as superficial, cosmetic, feminine. Before a painter was allowed to paint, he was expected to learn how to

render the human figure, first by learning the language of artistic tradition materialized by Antique sculptures or plaster casts, then by producing often extraordinarily polished drawings of live models who posed nude in the studios of their masters or in academic ateliers. (Women, as Linda Nochlin pointed out decades ago in a pioneering essay, rarely had access to such professional education.[1]) Having mastered these skills, accomplished students and established artists alike produced copious amounts of drawings not only in order to hone their powers of observation and to maintain or perfect their skills as draftsmen and experts in human anatomy, but also to think through and to work out the compositions of their most important pictures—the works with which they established their public reputations. At a time when pigments could be very expensive and paints and the surfaces upon which to apply them cost much labor to produce, one did not begin to work on a painting without a clear plan.

Despite the challenges to this tradition mounted by modernist and avant-garde artists, the academic drawing and preliminary study remained important components of artistic training and professional practice in German-speaking Europe until well into the twentieth century. This persistence of the academic tradition is suggested by several drawings in *Naked Truth*. The earliest is Gustav Klimt's sheet with two studies of a gracefully seated young woman of 1885 (Fig. 1, Chkl. 31), a drawing in pencil with white-chalk highlights that predates Klimt's turn to the opulent sensuousness and extreme ornamental flattening of the body that typified his pictures after 1900. Klimt's sequential disrobing (or robing) of the model, his suggestion of casual eroticism with one bare shoulder, and his elimination of the woman's facial features when she is shown wearing more than her underclothes are interesting. Of note here, though, are the drawing's immaculate finish and its concentrated working out of a solution to one problem, namely, how to approach the woman's right shoulder. Both are typical of academic drawing.

Closely related qualities are apparent in Egon Schiele's 1907 male-nude study (Fig. 2, Chkl. 49) and drawings in sharp pencil and luscious crayon made by George Grosz and Otto Dix in the mid-1920s when they were associated with the so-called "New Objectivity." In 1927, Dix drew a woman—his wife, Martha—giving birth (Fig. 3, Chkl. 16), using nervous lines that both model the figure and suggest a sense of immediacy. The pencil drawing recalls the frankness characteristic of Dix's shocking, controversial work in

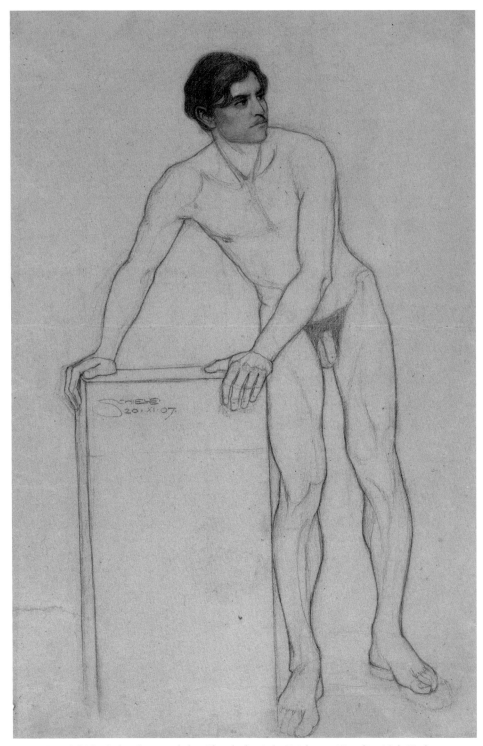

Fig. 2. Egon Schiele, *Stehender männlicher Akt, akademische Zeichnung* (*Standing Male Nude, Academic Drawing*), 1907. Pencil and charcoal, 28¹/₁₆ × 19½ in. Sabarsky Foundation.

Fig. 3. Otto Dix, *Geburt* (*Birth*), 1927. Pencil, 17¹³⁄₁₆ × 15¹⁄₁₆ in. Sabarsky Foundation. © 2015 Artists Rights Society (ARS), New York/VG Bild-Kunst, Bonn.

the early 1920s and indicates his interest in the female body in all its physicality—indeed, to the exclusion of any sign of individual consciousness or social identity. Yet, like Ferdinand Hodler's *Study for a Female Figure* (Chkl. 27) (but without the gridding to permit easy enlargement), Dix's drawing was very traditional in function, serving as one of several compositional studies that he made for a painting of the same year. Dix's use of tempera and translucent oil glazes in his paintings of the 1920s required that compositions, poses, and details all be carefully planned in advance. In the 1930s, Dix turned to a similarly demanding technique in drawing, namely, silverpoint, which permitted no erasure or alteration.

The Contours of the Avant-Garde: Life Drawing and Bohemian Identity

Between 1892 and 1914, the German and Austrian art worlds changed dramatically. Feeling crowded by the growing mass of their competitors, thousands of whose works competed for critics' and buyers' attention in the exhibitions organized in large cities every spring and fall, small groups of artists founded elitist secessions in Munich, Vienna, and Berlin between 1892 and 1898. These groups, which challenged the dominance of the traditional, democratically constituted associations that governed professional artistic life in the nineteenth century, were followed in turn by the emergence of Expressionist avant-gardes between 1905 and 1918. The secessions, led by such men as Gustav Klimt and Lovis Corinth, both of whom are well-represented in *Naked Truth*, faced resistance from imperial governments and traditional artistic institutions, but enjoyed the favor of sophisticates in high-bourgeois society. The Expressionist avant-gardes also possessed an "umbilical cord of gold," but the artists who constituted them defined themselves differently.[2] They cultivated the anti-bourgeois habitus of bohemia.

In particular, many Expressionist artists articulated their opposition to bourgeois society with uninhibited sexual behavior and its quasi-pornographic representation. Kokoschka and Schiele, the two *enfants terribles* of the Viennese art world, depicted exposed genitalia, lovers in intimate and even explicitly coital or immediately post-coital moments (Fig. 4, Chkl. 50), and, occasionally, scenes of sexual violence. George Grosz and Alfred Kubin envisioned decadent fantasies of sex and violence that verged on the obscene. The artists of Die Brücke (The Bridge), which formed in Dresden in 1905,

Fig. 4. Egon Schiele, *Liebespaar* (*Lovers*), 1913. Pencil, 18⅞ × 12⅝ in. Sabarsky Foundation.

made hundreds of drawings and prints of their girlfriends and models, often showing them lounging or cavorting with the scantily clad artists in the group's collective studio or in the German countryside (Fig. 5, Chkl. 43). Ernst Ludwig Kirchner and Erich Heckel were particularly fascinated by the bodies of pubescent or pre-pubescent working-class girls (Fig. 6, Chkl. 26). The many pictures they made of them must have been discomfiting to some viewers, much as contemporaneous texts on children's sexuality by Frank Wedekind and Sigmund Freud were.[3] They certainly are now.[4] In any case, Die Brücke's bohemian social dynamics and public artistic identity revolved around the production of images of the erotic, ostensibly unconstrained body.

It was not, however, only the "what" of these pictures that defined Die Brücke artists socially and artistically, but also the "how." In general, Kirchner's drawings, like Pechstein's watercolors and gouaches, are modernist in the emphasis that they place on the autonomy of their signifiers (primary and secondary colors, complementary color contrasts, and gestural lines), even as they still legibly depict nude bodies. More particularly, Kirchner's drawings

Fig. 5. Otto Mueller, *Sitzendes und zwei liegende Mädchen im Gras* (*One Seated and Two Reclining Girls on Lawn*), 1922–26. Lithograph, 12⅜ × 17⅛ in. Sabarsky Foundation.

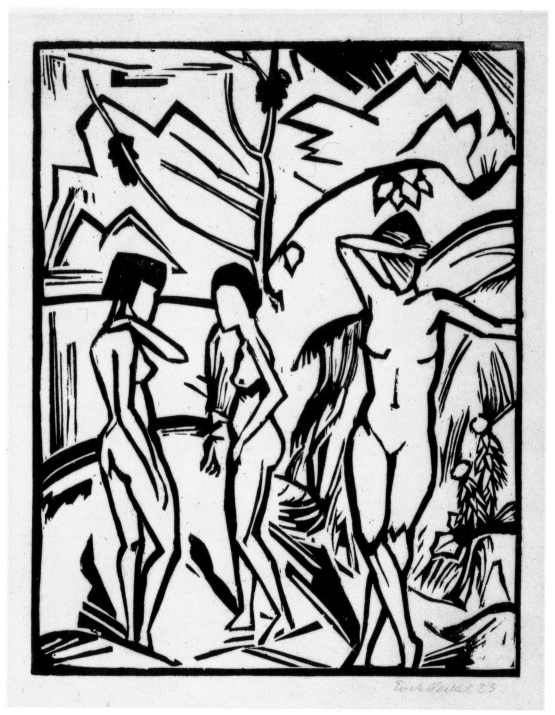

Fig. 6. Erich Heckel, *Drei Frauen am Wasser* (*Three Women near the Water*), 1923. Woodcut, 22¹³⁄₁₆ × 17⅜ in. Sabarsky Foundation. © 2015 Artists Rights Society (ARS), New York/VG Bild-Kunst, Bonn.

are especially good examples of Die Brücke artists' avant-garde break with academic tradition. The goal of academic practice, as we have seen, was to produce highly finished drawings of models in often conventional poses, which they had to hold for quite some time. Kirchner and his peers, on the other hand, sought to capture the fleeting, casual, everyday positions and movements of their friends and girlfriends with quick, energetic strokes of their pencils, colored pencils, and pastels. When they organized life-drawing sessions, poses lasted no more than fifteen minutes. Increasingly, they simply drew bodies as they encountered them in life, unposed. The loose, bold, abstracted style of the drawings that resulted—what Kirchner called their "hieroglyphic" character—thus marked an opposition to traditional cultural values and a countercultural commitment to youth, freedom, and authenticity.[5]

Sex in the City: Graphic Modernism and Mass Culture

Beginning in the mid-nineteenth century, modern artists increasingly turned away from the Biblical stories and Antique myths that had traditionally constituted the subject matter of the most ambitious and valued art. That is not to say that such material entirely disappeared, as Lovis Corinth's erotic etchings and lithographs of voluptuous Old Testament women and Max Pechstein's post-war woodcut portfolio illustrating the Lord's Prayer attest (Fig. 7, Chkl. 47). However, much of the most important art of the late-nineteenth and early-twentieth centuries depicted modern life. Artists responded with ambivalence to the transformation of the city and engaged critically with mass culture. The Impressionists and Neo-Impressionists celebrated the spaces of leisure in Paris and its environs. The Gallery Cubists tested the limits of realism in their pictures of café tables and bars. During the years between the world wars, Fernand Léger sought to represent the heroism of the modern worker with monumental paintings informed by the formal qualities of advertising.

Many of the pictures in *Naked Truth* are either nudes, isolated from their surroundings and unmarked by fashion, or seemingly timeless idylls. There are few if any humorous or horrifying realist descriptions of working-class people; Expressionist visions of city streets filled with erotic encounters; phantasmagoric objects; and desiring gazes; or images of playful, powerful,

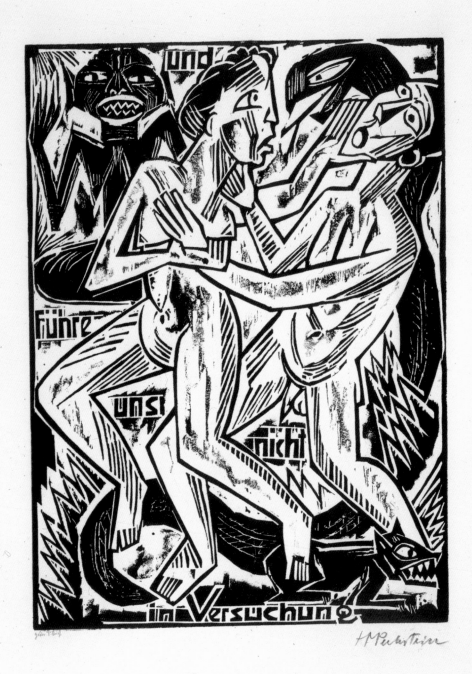

Fig. 7. Max Pechstein, *Das Vater Unser VIII—Und führe uns nicht in Versuchung* (*The Lord's Prayer VIII—And Lead Us Not into Temptation*), 1921. Woodcut, 23⅜ × 16⁵⁄₁₆ in. Sabarsky Foundation. © 2015 Artists Rights Society (ARS), New York/Pechstein Hamburg/Toekendorf/VG Bild-Kunst, Bonn.

or alienated New Woman fixed in the manner of the New Objectivity. However, several lithographs and etchings by Otto Dix and Max Beckmann of circus or freak-show themes point to the persistent engagement of German and Austrian artists with the experience of modernity, conceived in a characteristically modernist way. The prints exemplify the appeal of common things, ordinary and sometimes illicit pleasures, and urban spaces beyond the domain of bourgeois respectability. They materialize the modernist negation of entrenched cultural hierarchies—at modernism's best—by forcing the different aesthetics of modern mass culture and traditional high-artistic culture "into scandalous identity, each being continuously dislocated by the other."[6] Dix's depictions of circus performers employ the awkward proportions and simple techniques of graffiti and other forms of popular or naïve art. Beckmann's lithograph *Vor dem Auftritt (Akrobaten)* (*Before the Performance [Acrobats]*) (Fig. 8, Chkl. 4) combines the iconography of the circus—part of life in all "its meanness, its banality, its dullness, its cheap contentment, and its oh-so-very-rare heroism"—with the formal rigor and spatial order that Beckmann prized.[7] The figures of the man and woman are separate yet integrated, positioned within a compressed pyramid suggested by the network of vertically oriented diagonal lines behind them. Yet this compositional arrangement, traditionally associated with stability, is broken on the left, opened at the top, and tilted at the bottom. As is often the case in Beckmann's prints, the figures pressure their frames to produce strong formal and psychological tensions.

Yet, even as they exemplify important aspects of the modernist tradition in the visual arts in general, Beckmann's and Dix's prints—but also Grosz's matter-of-fact pencil drawing of a mundanely pre- or post-coital *Mann und Frau* (*Man and Woman*) (Chkl. 25)—exhibit the bitingly brutal, unsentimental, and grotesque qualities specific to much modern German art in the extremely turbulent, profoundly disorienting aftermath of the First World War. The female acrobat in Beckmann's print, arms akimbo and standing in casual contrapposto, exudes an attitude of relaxed confidence, oblivious to her weirdly effaced consort's monstrously contorted figure and alarmingly precarious position on a table about to topple. A similarly jarring discrepancy is visible in *Löwenpaar* (*Pair of Lions*) (Chkl. 3), in which the male lion's exultant roar of sexual gratification is matched neither by the indifferent expression on the female cat's face nor by the reduction of the imprisoned

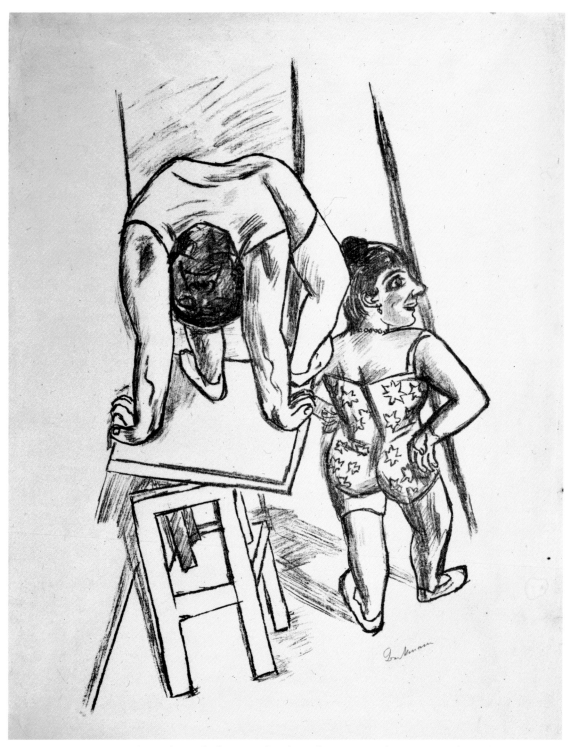

Fig. 8. Max Beckmann, *Vor dem Auftritt (Akrobaten)* (*Before the Performance* [*Acrobats*]), 1923. Lithograph, 22⁷/₁₆ × 14³/₁₆ in. Sabarsky Foundation. © 2015 Artists Rights Society (ARS), New York/VG Bild-Kunst, Bonn.

animals to a circus act. This beast is scarcely still regal. These critical pictures, often grouped in the 1920s under the rubric of Verism, are not seemingly spontaneously Expressionist images of natural eroticism. Sex is to be seen everywhere, openly, in the post-war, hyper-inflationary city, but almost always in tawdry, commodified, ironic forms.

Signs of Crisis: The Print in Post-War Germany

A bit more than half of the objects in *Naked Truth* are prints. One is a drypoint, closely related to the old technique of engraving in that it was about producing a groove and raised edge of metal to capture the ink that was then transferred to the paper by rolling the plate and paper through a press. Five are woodcuts, modern adaptations of the technique employed centuries earlier with virtuosity by Dürer and others. Eight are etchings, made with an *intaglio* technique like engraving and drypoint, but in which the incised plates are produced with acid rather than by the forceful physical manipulation of a tool.[8] Fourteen are lithographs, a print medium developed in the nineteenth century that allowed artists to make prints by drawing without particular physical exertion on a limestone slab with a greasy crayon or pencil: oil-based ink was attracted to the drawing, and repulsed by the blank areas of the stone when it was dampened with water. While the number of prints in this exhibition may be in part a function of what was available, printmaking was without question an important component of twentieth-century artistic practice in Germany and Austria, as it had been since the sixteenth century. Before the development of photography, prints had been used to reproduce works of art in faraway places. Woodcut broadsides had educated the literate and the illiterate in questions of politics, religion, and morality. Conceived as works of art in their own right, as they generally were in the twentieth century, prints provided affluent collectors with limited-edition objects of delectation and veneration. By permitting the distribution of multiple copies of a single image, they also maximized the potential financial returns on an artist's investment in time, labor, and materials.

This profitability was a crucial factor in the efflorescence of printmaking in Germany between the years 1918 and 1924, when many of the prints in *Naked Truth* were produced. The production of prints and print portfolios

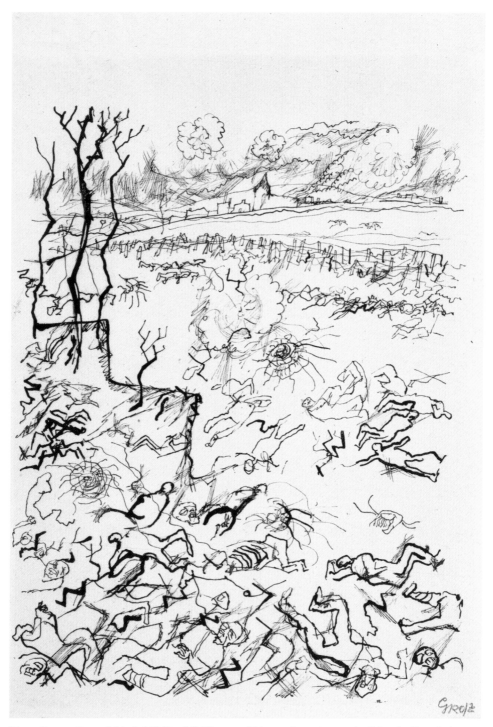

Fig. 9. George Grosz, *Schlachtfeld* (*Battlefield*), 1915. Lithograph, 12³⁄₁₆ × 9½ in. Sabarsky Foundation. Art © Estate of George Grosz/Licensed by VAGA, New York, NY.

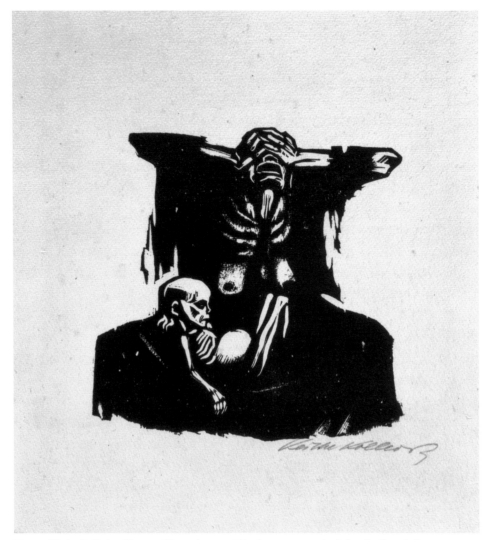

Fig. 10. Käthe Kollwitz, *Hunger (Hunger)*, 1923. Woodcut, 8¹¹⁄₁₆ × 9 in. Sabarsky Foundation.
© 2015 Artists Rights Society (ARS), New York/VG Bild-Kunst, Bonn.

had certainly thrived earlier.[9] Max Klinger had taken etching to new heights
of refinement in the 1890s. Corinth had made his flamboyantly sensual art
available to those who could not afford paintings, or who wished to look at
such things on an intimate, private scale. Between 1905 and 1913, Die Brücke
artists had revived the woodcut and made printmaking a central part of their
self-promotion. But it was only after the First World War that printmaking—
like quickly and cheaply produced works on paper in other media—achieved
an unusual prominence. Faced with inflation and then hyperinflation, many

wealthy Germans sought to protect themselves against the dizzying devaluation of the German currency by investing in luxury items that promised to retain or even gain value. Among them was art, and especially reasonably priced things such as prints by leading contemporary artists, whose work had begun to find its way into more and more private and public collections since the revival of the modern art market in the middle of the First World War. Beckmann, Dix, Grosz, Pechstein, and many others responded to the market demand. The boom in printmaking and sales in the late 1910s was thus a sign both of Expressionism's establishment and of Germany's crisis.

Economics was not the only motivating factor for German printmakers, though it certainly was a crucial one. With their images of mass death on the modern battlefield and of the traumatizing effects of grief on the families of those who were killed, artists like Grosz, Dix, and Käthe Kollwitz sought to intervene broadly in the highly politicized debate on how to remember the First World War (Fig. 9, Chkl. 22). The two prints by Kollwitz in *Naked Truth* are examples of her later work of the 1920s and 1930s, when she had moved from the subtle effects and intricate arrangements of detail in her etchings of the 1890s and 1900s to the schematic effects and simplified compositions of the woodcut in particular (Fig. 10, Chkl. 38). They also draw attention to one constant theme in her work, namely, the terrible suffering of (above all, working-class) children, whether as a result of famine or of a new, saber-rattling dictatorship that would grow ever more murderous as time passed. However, it should not be forgotten that Kollwitz's work before 1914 was as different in tone as it was in technique. Before the First World War killed one of her two sons and left her grief-stricken, Kollwitz brought into view more than the soul-crushing effects of hopeless poverty. She also suggested the transgressive pleasure taken by powerful women in the bloody revolutionary action with which they responded to class oppression and sexual assault. Those women's bodies do not make an appearance in *Naked Truth*. They are a story for another exhibition.

NOTES

1. Linda Nochlin, "Why Have There Been No Great Women Artists?" (1971), reprinted in Linda Nochlin, *Women, Art, and Power and Other Essays* (New York: Harper & Row, 1988), 145–78.

2. This—famous—characterization of the economic ties between the artistic avant-garde and the bourgeoisie was first formulated and published in 1939 by Clement Greenberg. See Clement Greenberg, "Avant-Garde and Kitsch," in *The Collected Essays and Criticism, Volume 1, Perceptions and Judgements, 1939–1944*, ed. John O'Brian (Chicago: University of Chicago Press, 1986), 5–22, esp. 10–11.

3. I am thinking here of Wedekind's scandalous *The Awakening of Spring*, which he wrote in 1891 but which was first performed in Berlin in 1906. I refer also to Freud's "Three Essays on Sexuality," written in 1905.

4. For an apologetic response to the recent expression of concerns about these paintings, prints, and drawings, see *Der Blick auf Fränzi und Marcella: Zwei Modelle der Brücke-Künstler Heckel, Kirchner und Pechstein*, ed. Norbert Nobis (Hannover: Sprengel Museum, 2010).

5. See E.L. Kirchner et al., "Brücke Program," and L. de Marsalle [E.L. Kirchner], "On Kirchner's Prints" (1921), reprinted in *German Expressionism: Documents from the End of the Wilhelmine Empire to the Rise of National Socialism*, ed. Rose-Carol Washton Long with Ida Katherine Rigby (Berkeley: University of California Press, 1993), 23, 144–47. Of course, as Carol Duncan pointed out in 1973, this freedom was for them, not necessarily their female models. See Carol Duncan, "Virility and Domination in Early Twentieth-Century Vanguard Painting," in Carol Duncan, *The Aesthetics of Power: Essays in Critical Art History* (Cambridge: Cambridge University Press, 1993), 81–108.

6. Thomas Crow, "Modernism and Mass Culture in the Visual Arts," in Thomas Crow, *Modern Art in the Common Culture* (New Haven: Yale University Press, 1996), 3–37 esp. 25–26.

7. Max Beckmann, "Creative Credo" (1918) and "Statement in the Catalogue of the Mannheim Kunsthalle Retrospective" (1928), in *Max Beckmann: Self-Portrait in Words*, ed. Barbara Copeland Buenger (Chicago: University of Chicago Press, 1997), 183–85, 294–95.

8. *Intaglio* prints are made by pressing ink into the incised lines on the plates, and then transferring that ink to the paper with the assistance of a press. In the case of woodcuts or linocuts, by contrast, the ink is applied to the areas of the original surface that remain after cutting. In intaglio prints, the incised lines are dark; in woodcuts and related techniques, they are light.

9. See, for instance, Robin Reisenfeld, *The German Print Portfolio 1890–1930: Serials for a Private Sphere*, exh. cat. The David and Alfred Smart Museum of Art, the University of Chicago (London: Philip Wilson Publishers, 1992).

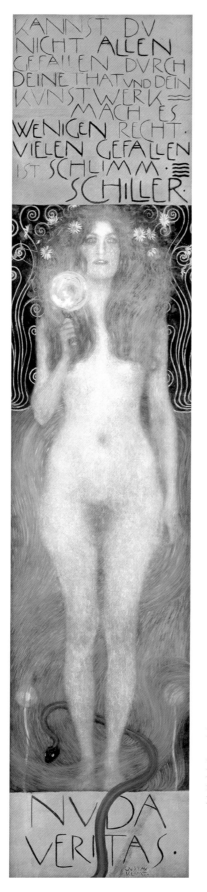

Fig. 1. Gustav Klimt, *Nuda Veritas (The Naked Truth)*, 1899. Oil on canvas, 96 × 22¼ in. Inv. ÖTM BT O 3656. Österreichisches Theatermuseum, Vienna. KHM–Museumsverband

Body Matters: Approaches to the Human Body in Early-Twentieth-Century German Discourse and Practice

Bettina Matthias

I N 1899, following the famous disputes over his so-called "Faculty Paintings,"[1] and the reworking of his 1898 print for the Vienna Secession's magazine *Ver Sacrum*, Austrian painter Gustav Klimt exhibited his oil painting *Nuda Veritas* (Fig. 1) at the Secessionists' second annual show. Daring, provocative, and programmatic, the painting stirred a great deal of controversy, and its exegesis continues to our day. The beautiful pale nude keeps her onlooker caught in a strange state of suspense between seduction and rejection. Her long and heavy, loose red hair adorned with spring flowers, her half-open lips and made-up eyes, her curvy contours and her pubic hair, in combination with a snake at her feet and organic ornamentation in the background, all invite the objectifying gaze to declare her the ultimate sexual object and seductress, the original Eve, the perfect fusion of woman and art in the tantalizing nude. However, her strangely rigid posture, her "guileless gaze directed at the observer," her almost lifeless paleness and her "size, requiring most observers to look up in order to take her in"[2] counter the effect of female objectification by the (male) gaze and establish an endless interplay between the onlooker and the one being looked at that might have been responsible for the uneasiness the painting caused Viennese society when it was unveiled. At once "rendered and rendering," this *Nuda Veritas* challenges the onlooker to question his or her traditional ways of taking in a nude (or naked) female body; the mirror she holds in her hand, facing the viewer, reinforces the sense that this painting is much more about how we look than what we look at. Steeped in a long tradition of female nudes in European painting, Klimt's *Nuda Veritas* eschews attempts to fully categorize her as a sexual body on a canvas and instead makes clear that any such reading originates in us. Much more than just an allegory for the Secessionist movement's new

aesthetics, Klimt's *Nuda Veritas* marks an important moment in the history of German-Austrian body culture, its discourses, and its practices. Indeed, it calls for an inquiry into approaches to the naked body that became a locus of public debate, cultural reform, and aesthetic experimentation in the German-speaking countries around the turn of the century.

To fully understand the significance of Klimt's challenge, and its place in the multifaceted discourse over and on the body, it is important to remember the meanings that had been accorded the naked body over centuries. Inscribed in stable conceptual paradigms defined by religion, gender politics, economics, medicine, and aesthetics, the body—and especially the female body—had been readily readable by the dominant male gaze. Virgin, mother, and whore were variants on the biologically, functionally defined interpretive mold of the curvy female body. The male body, on the other hand, enjoyed associations with virtues such as strength, courage, or heroism established in Ancient Greek sculpture (500 BC to about 325 BC) well into the twentieth century and beyond. The athletic-heroic male body and the fertile-seductive female body dominated much of Western art and thought for centuries, and gender discourses and practices both took their cues from such representations and in turn reinforced their survival. In this system, the naked female body, aestheticized as the nude, was always-already associated with sexuality, and though painters like Édouard Manet (1832–1883), with his *Déjeuner Sur l'Herbe* (1862–63) and his *Olympia* (1865), scandalized the public with the frankness, honesty, and "vulgarity" of their depictions, their bodies invited—instead of defied—the erotic gaze and reinforced stable notions of the relationship between the naked body and sexuality.

This relatively unquestioned nexus, both completely familiar and, in its blanket acceptance, completely opaque, started to become both an issue and an opportunity towards the end of the nineteenth century. When Europe began to feel the full effects of modernism—industrialization, urbanization, the scientific rationalization of life, materialism, annihilation of time and space through means of modern technical advancements—the German-speaking countries turned to the human body and its experiences to search for a new identity. As Karl Toepfer points out in the introduction to his monumental edited volume *Sexual Experience and Body Culture: German Language Publications 1880–1932,* "[t]he self-conscious attempt by Western civilization in the nineteenth century to construct a 'modern' identity for itself and to

define modernity as a necessary alternative to the oppressive authority of the past,"[3] not only led to what Carl. S. Schorske, in his *Fin-de-Siècle Vienna: Politics and Culture* famously called the (psychological) "turn inward" of the younger generation in Austria.[4] Especially in the new nation-state of Germany, the body became the locus over and through which an increasingly polyphonous choir of voices also tried to define the modern self and meaning as people were grappling with the vastly unsettling phenomena and effects of modernism.[5] Targeting the one human experience that had been inscribed in a strict and stable paradigm over the course of centuries, "[m]odernity [now] raised the question of whether sexual experience is an historical phenomenon, the agent or object of socio-cultural change, or a 'natural' phenomenon, impervious to any notion of a modern expression of it. . . . Among German speakers, a new or modern discourse on sexuality entailed new, emancipated ways of looking at the body and of understanding the 'meaning' of the body. Sexual culture became inextricably entangled with body culture."[6] In other words, the attempt to understand sexual experience in new ways led to the discovery of the body in a much broader sense and to the questioning of established patterns of understanding, conceptualizing, and representing it. The resulting veritable explosion of discourses, approaches, and practices contributing to the realm of body culture provokes reevaluation of contributions from the visual arts not only as responses to aesthetic needs and challenges in the twentieth century, but as part of "an increasingly crowded and confused cultural space in which the body consistently triumphed as a source of difference rather than sameness."[7]

In the following, I will outline some of the discourses and practices that contributed to this "confused cultural sphere," a sphere that was, according to Toepfer, dominated by "two large categories: nudity and movement."[8] These dominant drives managed to bridge otherwise very different cultures—Austria and Germany—as well as traditionally sharply distinguished time periods—pre- and post-First World War. Though increasingly diversified, or "confused" in Toepfer's terms,[9] and peaking in Weimar Germany's vibrant and almost all-encompassing inclusion of the (dynamic) body in all aspects of conceptualizing and living life, the "remarkable firmness of purpose"[10] assigned to the project of modern body culture presents a fascinating counter-narrative to established ways of conceptualizing (cultural) history along event-based lines. Neither the war nor geographical borders posed serious

challenges to the modern exploration of the body's potential. It would take Adolf Hitler and his Nazi regime to affect such change and to misappropriate a movement that was built on the notions of liberation, diversification, and exploration.

One of the main, if not the main discerning feature of modern approaches to the body was the desire to liberate it from its previous "entrapment," conceptual or actual. Whether in fashion or in dance, in painting or in literature, on the stage or in everyday life, corsets—literal and symbolic ones—were thrown off, and the body, in its full corporality, mobility, and sensuality, became the focus of attention. In the visual arts, academic and photographic-realist approaches to the body were frequently replaced with much more subjective, open ones, often revealing it as "undisguised flesh and blood" in search of the "'true' nature of humanity."[11] Klimt's sensual nudes, such as *Mit angezogenen Schenkeln kauernder Mädchenakt* (*Crouching Nude Girl with Pulled-Up Thighs*), 1903 (Fig. 2, Chkl. 33), still suggests psychological rather than physical transgression, but many of Egon Schiele's nudes exhibit a combined psycho-erotic-anatomic approach, cutting through established traditions of representation of the naked body, peeling back layers of clothing, and ultimately even skin, in search of the essence of the body itself. Though not included in the exhibition, his *Sitzender männlicher Rückenakt* (*Seated Male Nude from the Back*), 1910 (Fig. 3) is a gripping example of this unbridled and transgressive approach to the human body, and it is characteristic of much of Schiele's post-academic work.

The desire to liberate the body from the exigencies of traditional notions of beauty and containment is even more visible in works by Klimt's and Schiele's German colleagues. Especially Otto Dix pushed the limits of the nude as a genre in his grotesque images of big-chested naked women, mostly prostitutes. His *Weiblicher Halbakt* (*Female Semi-Nude*), 1923 (Fig. 4, Chkl. 14), may be the most striking example of what Mikhail Bakhtin (1895–1975) in his influential treatise *Rabelais and His World* (1965) called the "dialogical" or "grotesque body" of pre-modern times.[12] After centuries of "taming" the body into what Bakhtin calls the "monological body" of modernity, we see, once again, in Dix's lithograph, a body that is "not a closed, completed unit; it is unfinished, outgrows itself, transgresses its own limits. . . . This means that the emphasis is on the apertures or the convexities, or on various ramifications and offshoots: the open mouth, the genital organs, the breasts,

Fig. 2. Gustav Klimt, *Mit angezogenen Schenkeln kauernder Mädchenakt* (*Crouching Nude Girl with Pulled-Up Thighs*), 1903. Blue and red pencil, 12¹⁄₁₆ × 17⁹⁄₁₆ in. Sabarsky Foundation.

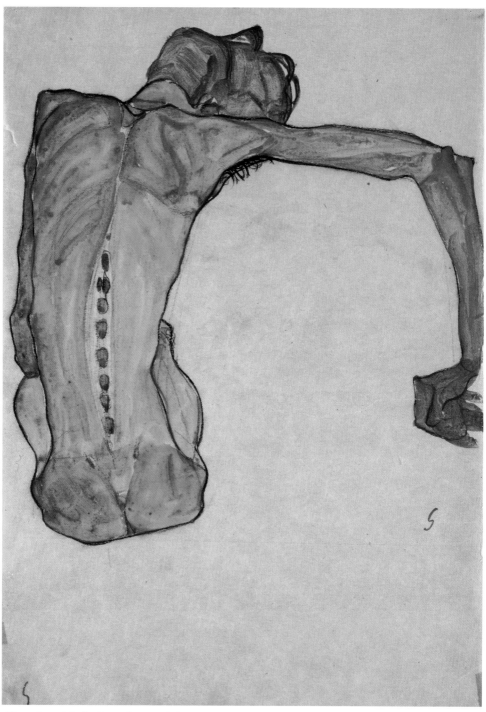

Fig. 3. Egon Schiele, *Sitzender männlicher Rückenakt (Seated Male Nude from the Back)*, 1910. Watercolor, gouache, and black crayon, 17¼ × 12¼ in. Sabarsky Foundation.

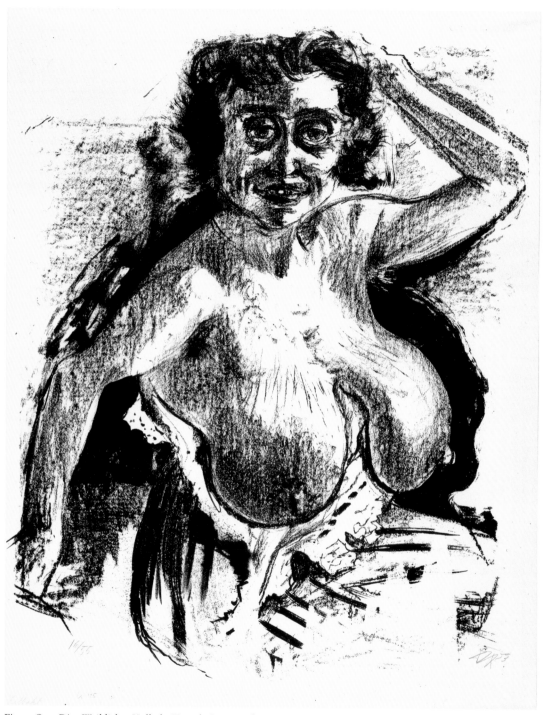

Fig. 4. Otto Dix, *Weiblicher Halbakt* (*Female Semi-Nude*), 1923. Lithograph, 23⅝ × 19⁵⁄₁₆ in. Sabarsky Foundation.
© 2015 Artists Rights Society (ARS), New York/VG Bild-Kunst, Bonn.

the phallus, the potbelly, the nose."[13] Clearly blasting the confines of any figure-shaping contraption—a bra or a corset, but also traditional aesthetics of the nude—this body forces itself onto the viewer almost violently and suggests itself as a cipher for a new body culture that defined more than just the spectrum of that which should be deemed erotic or sexually stimulating.

An uncanny and sobering connection exists to a very different kind of "dialogical body" whose (psychological) presence influenced the way people thought and talked about bodies after the First World War: the mutilated and decaying body, most grippingly depicted again by Dix in his anti-war etchings such as *Leiche im Drahtverhau* (*Dead Body in a Wire Entanglement*), 1924, or *Sterbender Soldat* (*Dying Soldier*), 1924 (Fig. 5, Chkl. 15). Haunted by the memory of fellow soldiers who had lost their lives on the gas-poisoned battlefields of Belgium, Dix started drawing, etching, and painting a series of such corpses in the early 1920s. Both devastating and grotesque, these depictions were among the more drastic impressions of a new physical reality in Germany, as thousands of mutilated war veterans lined the streets, begging for sustenance and charity in a country that could not sufficiently care for those who had literally given an arm and a leg, and where ubiquitous mechanical prostheses questioned and expanded the definition of the human body. Fallen heroes of a fallen country, these men did not resemble their Greek forefathers. And though this aspect of post-war body culture does certainly not fall into the category of a liberating turn towards more "flesh-and-blood" approaches to the nude body or show the body in movement, it represents an important contribution to the "increasingly crowded and confused cultural space"[14] that was the realm of body culture after the war. Offering heart-wrenching depictions of medical progress in the areas of surgery and prosthetic innovations, and providing evidence of the perverse idea that bodies in wartime are nothing but cannon-fodder, these depictions of mutilated bodies and corpses rotting on former battlefields seared the traumatized nation's psyche even as they expanded the definition of what a body might be and signify. Depictions of death and decay, too, must be considered in discussions of the modern body culture, particularly after the war—an insight that the German poet Gottfried Benn (1886–1956) invoked as early as in 1912, for example in his poem "Schöne Jugend" ("Lovely Childhood") from the collection titled *Morgue*, composed when he was a young doctor at a morgue in Berlin-Moabit:

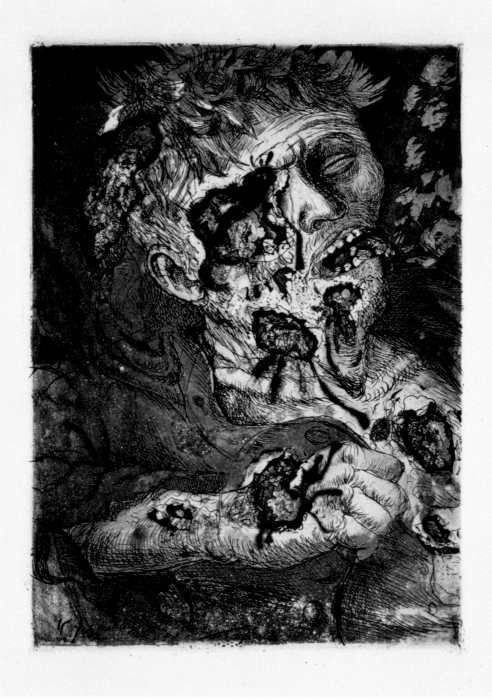

Fig. 5. Otto Dix, *Sterbender Soldat* (*Dying Soldier*), 1924. Etching, 18⅞ × 14³⁄₁₆ in. Sabarsky Foundation.
© 2015 Artists Rights Society (ARS), New York/VG Bild-Kunst, Bonn.

Der Mund eines Mädchens, das lange im Schilf gelegen hatte,
sah so angeknabbert aus.
Als man die Brust aufbrach, war die Speiseröhre so löcherig.
Schließlich in einer Laube unter dem Zwerchfell
Fand man ein Nest von jungen Ratten.
Ein kleines Schwesterchen lag tot.
Die andern lebten von Leber und Niere,
Tranken das kalte Blut und hatten
Hier eine schöne Jugend verlebt.
Und schön und schnell kam auch ihr Tod:
Man warf sie allesamt ins Wasser.
Ach, wie die kleinen Schnauzen quietschten!

The mouth of a girl who had long lain among the reeds
Looked gnawed away.
As the breast was cut open, the gullet showed full of holes.
Finally, in a cavity below the diaphragm
A nest of young rats was discovered.
One little sister lay dead.
The others thrived on liver and kidneys,
Drank the cold blood and [had]
Enjoyed a lovely childhood here.
And sweet and swift came their death also:
They were all thrown into the water together.
Oh, how the little muzzles squeaked![15]

Reminiscent of Charles Baudelaire's *Fleurs du Mal* (1857) and especially his gripping poem "Une Charogne," Benn's poems point to the body's place in modernism's quest for a new definition of body and self, later further amplified by the war. Scopophilia borders necrophilia in these poems, much like in Alfred Kubin's disturbing lithograph *Die Selbstmörderin* (*Female Suicide*), 1922 (Fig. 6, Chkl. 40). The lithograph's complex iconography and almost palpable olfactory qualities (created through the juxtaposition of the suicide victim and the fish upon which the body is placed) share affective qualities with Dix's corpses and mutilated bodies; none signal a safe modern identity. The holes in the soldiers' skin render absurd the idea of a life-embracing

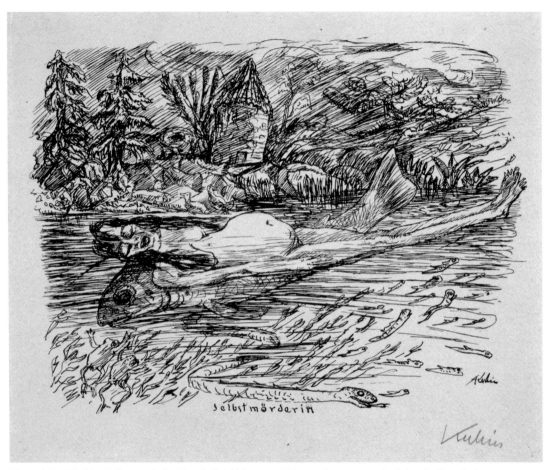

Fig. 6. Alfred Kubin, *Selbstmörderin* (*Female Suicide*), 1922. Lithograph, 11 × 13⅜ in. Sabarsky Foundation.
© 2015 Eberhard Spangenberg/Artists Rights Society (ARS), New York/VG Bild-Kunst, Bonn.

"dialogical body"; the dead female body, either inflated by water or infested with rats, betrays the gaze that beholds it as most problematic if not deadly.

Liberating the body from established concepts in the visual arts thus led to a diversification of both aesthetics and messages that aligned with the radically changing reality of post-1880 Europe. The broader modernist discourse on the body, however, also involved more life-affirming variants and included responses to modernism that both embraced its tendencies and strongly rejected them to offer alternative modes of physical (and sexual) existence: the body was conceptualized both as machine and as purely natural organism, and everything in between. The thread common to all, as noted earlier, was the idea of movement.

Also called "the age of technology," the early-twentieth century, and especially the interwar years, were characterized by significant changes in industrial methods of production, in the ways labor was divided and time and space were conceived. The introduction of Taylorist and Fordist production practices helped jumpstart German industry after the war and had a significant impact on the ways in which people understood their contributions to the production process. Pushing Adam Smith's (1723–1790) ideas on the division of labor to new levels, modern industrial reality engaged thousands of laborers in assembly-line mass production to build standardized products using specialized tools to perform particular tasks over and over. Relatively good wages enabled workers to purchase the products they helped build, creating a perfectly closed system in which people could conceive of themselves only as part of this cycle. The human body and the machine that it operated became one, both as a consequence of and also as a precondition for such production.[16] Workers began to conceptualize their bodies as "Arbeitsmaschinen," as production machines. The robot—perhaps most richly imagined in Fritz Lang's movie *Metropolis* (1927)—became a symbol of physical precision and perfection to which the human body could only aspire, a model that also helped to inspire new regimens in physical education and dieting. But the idea of the body as a machine, and of bodies as parts of a bigger machine, also found expression in cultural phenomena such as the "girls troupes" (like the "Tiller Girls") of European variety theaters. As Siegfried Kracauer (1889–1966), in his seminal essay "The Mass Ornament" from 1927, explained: "These productions of American distraction factories are no longer individual girls but indissoluble girl clusters whose movements

are demonstrations of mathematics."[17] No longer did the individual body determine the dance and the movement to be performed. The movement itself, its machine-like aesthetics and precision, determined the character of the body, reversing the natural order between movement and physique and reducing it to its most usable and flexible parts. A dangerous (and in Kracauer's view, fascist) sense of dehumanization governed these human "mass ornaments" and may have been partially responsible for what Karl Toepfer calls "[modernity's] impulses toward abstraction and a consequent estrangement from the body itself as a source or site (rather than simply a sign) of historical tensions."[18] Even though Toepfer successfully demonstrated that the idea of abstraction was just one point of germination for many formulations of body culture in the early-twentieth century, performances such as those by the girls troupes, and radically abstract artistic-technical approaches to the body like the one put forth in Willi Baumeister's *Sitzende Figur* (*Seated Figure*), 1921–22 (Fig. 7, Chkl. 1) illustrate the significant connections between modernist life and concepts of the modern body.

But no matter how abstract the particular concept of the body, it could always be made visible and brought to life by movement, especially in dance. A vibrant dance culture was very much at the center of early-twentieth-century body culture and expressed in a dynamic medium the general desire to liberate the body: ranging from standardized girls troupes' performances to abstracted bodies in motion in Oskar Schlemmer's (1888–1943) Bauhaus ballets, to vastly popular social dances like the Shimmy or the Charleston, to the innovative approaches taken by dance artists like Mary Wigman (1886–1973) or Rudolph Laban (1879–1958), the spectrum was vast and exhilarating. On a much larger scale, Lebensreform, or the Reform Movement, started in the 1870s, had already promoted a similar combination of body and movement as well as nudity as a health and lifestyle initiative, attracting tens of thousands of followers by the 1920s.

Harking back to ideals promoted by eighteenth-century Swiss philosopher Jean-Jacques Rousseau (1712–1778), the Reform Movement was a direct response to the felt negative consequences of modernism's effects on life. Urbanization—with its traffic, pollution, and noise—mechanization, materialism, and the emergence of the anonymous social mass in the city all ran counter to the ideas of a healthy life, and, just like Rousseau, early reformers such as the painter Karl Wilhelm Diefenbach (1851–1913) called

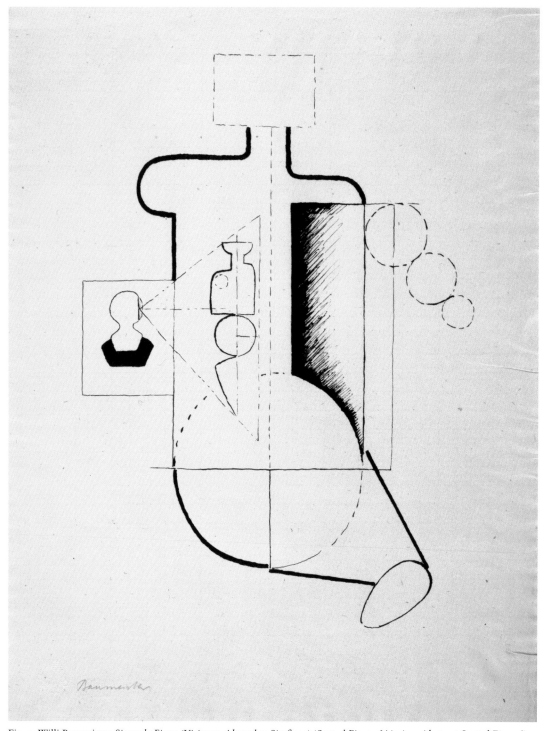

Fig. 7. Willi Baumeister, *Sitzende Figur (Visieren, Abstrakte Sitzfigur)* (*Seated Figure [Aiming, Abstract Seated Figure]*). , 1921–22. Lithograph, 15⅜ × 10¹³⁄₁₆ in. Sabarsky Foundation. © 2015 Artists Rights Society (ARS), New York/VG Bild-Kunst, Bonn.

for a return to natural ways of being. Committed to living in harmony with nature, he promoted veganism, nudism, physical activity under the open sky, and even polygamy. Together with his protégé Hugo Höppner, alias "Fidus" (1868–1948), he lived in a quarry close to Munich, celebrating nakedness and eventually attracting a group of followers. As visual artists, the two promoted their program through works such as Diefenbach's influential shadow frieze *Per aspera ad astra* (1893), which depicted an idealized large group of Germanic-looking naked people gazing at the stars, seemingly longing for a better life close to nature.

The defining feature of the Reform movement was its rejection of modern civilization's restrictive influences. Modern urban life, machines, the sciences—but also the restrictive fashion of the late-nineteenth and early-twentieth centuries, with its corsets, chokers, and narrow shoes—all meant a person's and body's alienation from his or her natural purpose and inner equilibrium. Calls for new clothing (women's dress, underwear, and shoes) as well as the founding of nudist clubs and colonies (the first one in Klingberg/Schleswig Holstein, in 1903) made the movement increasingly popular. Well-illustrated publications by charismatic leaders such as Richard Ungewitter (1869–1958) or Heinrich Pudor (1865–1943) promoted physical exercise in fresh air and so-called "light baths," that is, taking a bath in the sunshine, preferably in the nude. In spite of Wilhelmian Germany's prudish and morally strict reputation, Germans engaged actively in this new and liberal approach to the human body, and by 1912 there were over 500 nudism clubs and organizations nationwide for people to join.[19]

What might look like a thinly veiled excuse for some of its leaders' desire to indulge in the sight of the naked (female) body in traditionally sexualizing and objectifying ways was yet an honest attempt on the part of many of the Reform movement's followers to expand and explode these notions and attain a new level of existence, a pre-civilized way of liberated physical being and innocent coexistence of the genders. The members of Munich's artist association Die Brücke enthusiastically embraced the Reform Movement and nudism as one of its main tenets. Images such as Otto Mueller's *Knabe vor zwei stehenden und einem sitzenden Mädchen (Boy in Front of Two Standing and One Seated Girl)*, circa 1919 (Fig. 8, Chkl. 41), or Max Pechstein's *Am Strand (At the Beach)*, 1922 (Fig. 9, Chkl. 48) illustrate the importance of this movement for these artists and the period's aesthetics. Of all the discourses

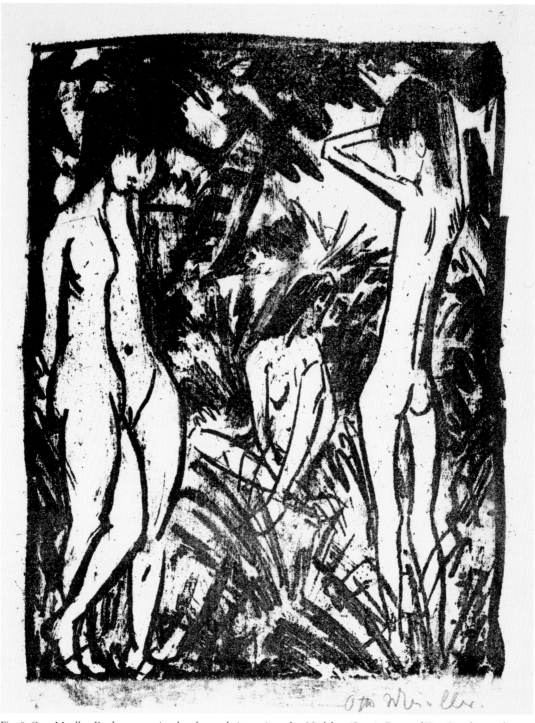

Fig. 8. Otto Mueller, *Knabe vor zwei stehenden und einem sitzenden Mädchen* (*Boy in Front of Two Standing and One Seated Girl*), ca. 1919. Lithograph, 21⅝ × 17½ in. Sabarsky Foundation.

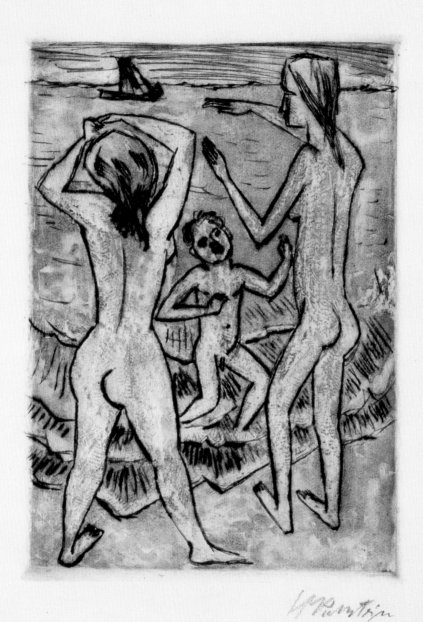

Fig. 9. Max Pechstein, *Am Strand* (*At the Beach*), 1922. Etching, 14¾ × 11¾ in. Sabarsky Foundation.
© 2015 Artists Rights Society (ARS), New York/Pechstein Hamburg/Toekendorf/VG Bild-Kunst, Bonn.

and practices that redefined the body in modern times, Lebensreform was the one with the widest appeal for the German-speaking public and the one that most deeply permeated German society.

Later permutations of the movement and its focus on the very fit body would veer dangerously close to ideas of eugenics and align with Nazi theories on race, a deplorable affiliation that clouds the significance of the Reform Movement as a vanguard of later twentieth-century efforts to promote a more relaxed and self-determined approach to the body. The lasting popularity of nudism (in the free body culture, or "Freikörperkultur" (FKK) whose influence lasts even today) and open-air physical education in Germany, however, bear testimony to this important development in early-twentieth-century body culture.

As this cursory survey of select approaches to the body in the early-twentieth century has shown, the spectrum of possible conceptions of the body was as wide-ranging as the times in which they emerged were turbulent. Concepts of the human body ranged from completely abstract to organic, from overly sexualized to paradisical and innocent ones, from visions of the revived "dialogical body" of centuries past to devastating *memento mori* and precursors of today's bionic bodies. Discourses and cultural practices oscillated between historical paradigms and the desire for a history-free, new physical reality. The common denominators were movement and nudity; the common goal was liberation. The works in the exhibition invite you to explore this "crowded and confused cultural space" and enjoy their idiosyncrasies and suggestions.

NOTES

1. In 1894 Klimt was commissioned to paint the ceiling of Vienna's new University building on the Ringstrasse. His allegorial depictions of the University's core faculties—Philosophy, Medicine, and Jurisprudence—caused major controversy in Vienna's academic and political circles for their "pornographic" tendencies (in all three, Klimt featured a number of very provocative nudes). The panels were rejected, then moved around from Klimt's home to private collectors to a small castle near Vienna (Schloss Immenhof) before they were destroyed in a fire set by retreating SS forces in 1945.

2. Patricia Mooney Nickel, "Public Intellectuality: Academics of Exhibition and the New Disciplinary Secession," *Theory and Event* 12, no. 4 (2009), http://muse.jhu.edu/journals/theory_and_event/vo12/12.4.nickel.html. Accessed January 16, 2015.

3. Karl Toepfer, ed. "Sexual Experience and Body Culture. German Language Publications 1880–1932. Historical Sources of Womens' Liberation Movement and Gender Issues, HQ 63," http://www.harald-fischerverlag.de/hfv/HQ/hq63_engl.php. Accessed October 4, 2014.

4. Carl S. Schorske, *Fin-de-Siècle Vienna: Politics and Culture* (New York: Knopf, 1980), 9.

5. I am using the term "modernism" in the way Toepfer seems to be using "modernity." Technically, these two terms are different, though no unanimous definition exists. Peter Childs, in his concise introduction to modernism, suggests that modernity is a term that describes a post-Enlightenment period. He

writes: "More generally, modernity is an imprecise and contested term. . . . Modernity describes the rise of capitalism, of social study and state regulation, the belief in progress and productivity leading to mass systems of industry, institutionalization [*sic*], administration and surveillance." Modernism, on the other hand, "has . . . frequently been seen as an aesthetic and cultural reaction to late modernity and modernization." In lay terms, modernity thus covers a much longer period and a broader spectrum of social and cultural phenomena than modernism, which roughly covers the artistic and cultural responses during decades around the turn of the twentieth century. Peter Childs, *Modernism* (London and New York: Routledge, 2000), 16.

6. Toepfer, 1–2.

7. Karl Toepfer, *Empire of Ecstasy. Nudity and Movement in German Body Culture, 1910–1935* (Berkeley, CA: University of California Press, 1997), 6.

8. Toepfer, *Empire of Ecstasy*, 7.

9. Toepfer, *Empire of Ecstasy*, 6.

10. Toepfer, *Empire of Ecstasy*, 9.

11. Max Hollein, "Foreword," in *The Naked Truth. Klimt, Schiele, Kokoschka and Other Scandals*, eds. Tobias G. Natter and Max Hollein (Munich: Prestel, 2006), 11.

12. Mikhail Bakhtin, *Rabelais and His World*, trans. Hélène Iswolsky (Bloomington, IN: Indiana University Press, 1984).

13. Bakhtin, *Rabelais*, 26–27.

14. Toepfer, *Empire of Ecstasy*, 6.

15. Gottfried Benn, *Primal Vision, Selected Writings of Gottfried Benn*, ed. E. B. Ashton, trans. Babette Deutsch (New York: New Directions, [1960]), 212–15.

16. Michael Cowan and Kai Marcel Sicks, "Technik, Krieg und Medien: Zur Imagination von Idealkörpern in den zwanziger Jahren," *Leibhaftige Moderne: Körper in Kunst und Massenmedien 1918 bis 1933* (Bielefeld: Transcript Verlag, 2005), 16.

17. Siegfried Kracauer, "The Mass Ornament," *The Mass Ornament, Weimar Essays*, ed. and trans. Thomas Y. Levin (Cambridge, MA: Harvard University Press, 1995), 76.

18. Toepfer, *Empire of Ecstasy*, 6.

19. Jürgen Overhoff, "Nudismus: Im Lichtkleid zum Lebensglück," *Zeit Online* 02/2013, http://www.zeit.de/zeit-geschichte/2013/02/freikoerperkultur-nudismus-lebensreform-kaiserreich. Accessed January 6, 2015.

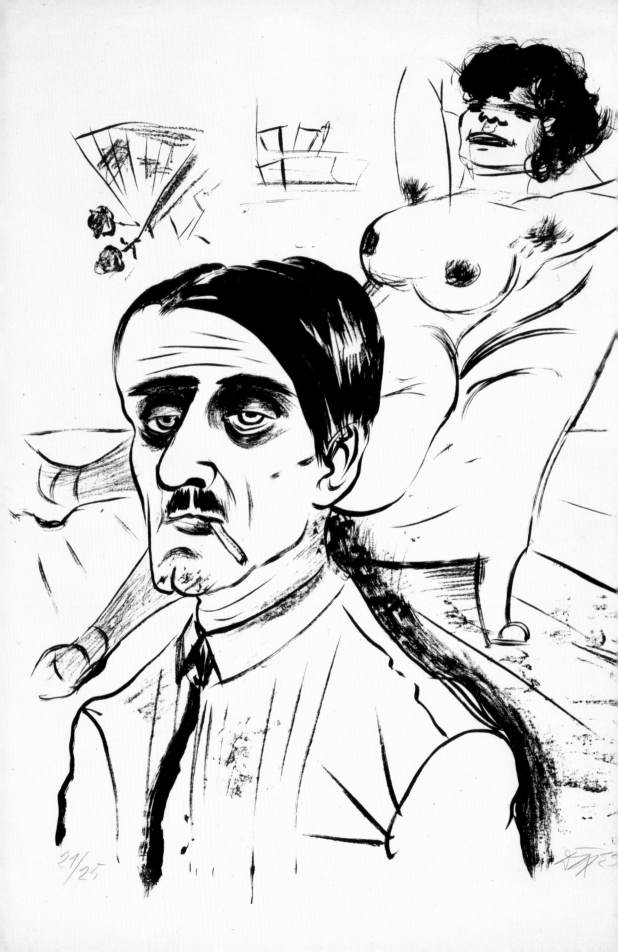

21/25

States of the Body in the Work of George Grosz and Otto Dix

Eliza Garrison

IF, TO PARAPHRASE T. J. CLARK, by the middle of the nineteenth century, the nude as a category was losing whatever clarity it might once have had, by the early twentieth century in Germany and Austria, the nude body, and particularly the nude female body, was a site where male artists worked out, worked through, and gave visual form to modern political and social anxieties.[1] In many cases, the nude body *embodied* ideas far removed from traditional notions of love, fertility, and a sense of intimate ease. In the hands of artists such as George Grosz and Otto Dix, for example, the unclothed female body alludes to and bears the marks of war, disease, and depredation more generally. In the work of Grosz and Dix, the unclothed female body may reference sex, but it is often anything but conventionally sexy.

In order to appreciate the alternative that both artists offered, it is helpful to turn briefly to the work of Gustav Klimt and Egon Schiele, two artists whose practice and treatment of the body, while not identical, are closely related to one another. In several of Klimt's studies in this catalogue, we see a view of the nude that is both distinctly of its time yet still tied to academic tradition. Even when Klimt's female nudes are removed from the surroundings that they would take on once they were rendered in paint, images such as his *Mit angezogenen Schenkeln kauernder Mädchenakt* (*Crouching Nude Girl with Pulled-Up Thighs*) (Fig. 1, Chkl. 33) and his *Stehender Mädchenakt mit vorgebeugtem Körper nach links* (*Nude Girl Standing with Body Leaning Over, Facing Left*) (Fig. 2, Chkl. 32)—both of which are studies for larger paintings—are still rooted in the representation of Woman not as an individual but as a passive embodiment of male fantasy. She is the yielding object of the heterosexual male gaze, and she is always youthful, flawless, pliable, and anonymous. Ultimately, not much separates Klimt's young women from the academic Venuses and Aphrodites from which they are ultimately derived. Whether his razor-sharp gaze was turned to himself or to models in

Fig. 1. Gustav Klimt, *Mit angezogenen Schenkeln kauernder Mädchenakt* (*Crouching Nude Girl with Pulled-Up Thighs*), 1903. Blue and red pencil, 12¹⁄₁₆ × 17⁹⁄₁₆ in. Sabarsky Foundation.

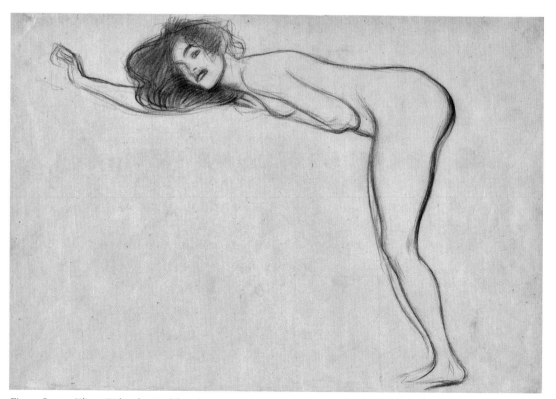

Fig. 2. Gustav Klimt, *Stehender Mädchenakt mit vorgebeugtem Körper nach links* (*Nude Girl Standing with Body Leaning Over, Facing Left*), ca. 1900. Black chalk, 12¹⁄₁₆ × 16¹⁵⁄₁₆ in. Sabarsky Foundation.

his studio, Egon Schiele's treatment of the nude often emphasized the physicality of sex and sexual activity. Schiele's *Liebespaar* (*Lovers*) (Fig. 3, Chkl. 50), which he sketched in 1913, exemplifies both, even if it is less explicit than many of his other nude drawings. As in Klimt's work, the female figure's attention is directed at the viewer of the scene, whom the woman in the image seems to invite to take the place of the man on top of her. While Schiele devoted a great deal of attention to rendering her face, he used only a few strokes of his pencil to suggest the features of her male partner.

Scrutinizing the nude and variously clothed bodies of Grosz and Dix in this catalogue and in the rest of their work, one sees the body—whether male or female—become a metaphor for the body politic and for capitalist excess. (Dix identified with leftist ideals but never with an explicit ideology; Grosz was a member of the Communist Party.) The body and the nude all bear the scars and marks of life; in some cases those are the wounds of war, in others they are the marks of a life lived at the edge of existence, in still others the body's carnivalesque appearance seems only vaguely to mask perversions of all kinds. Satirical though they often were, these images gave form to violent and threatening aspects of lived experience in the years leading up to and following the First World War. This was a world that would seem to be far removed from the decorative erotic male fantasy of Klimt and the aggressively pornographic sexuality of Schiele.[2]

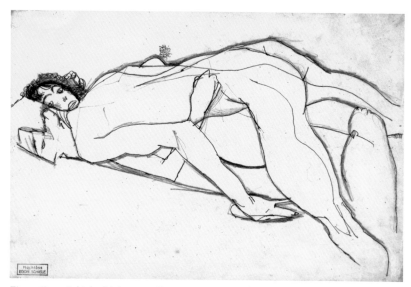

Fig. 3. Egon Schiele, *Liebespaar* (*Lovers*), 1913. Pencil, 18⅞ × 12⅝ in. Sabarsky Foundation.

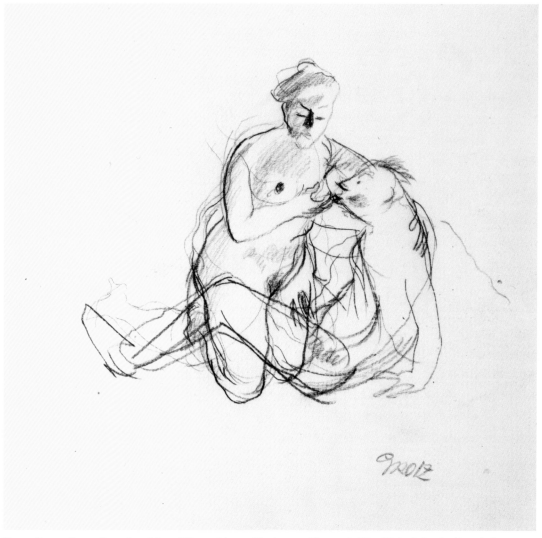

Fig. 4. George Grosz, *Frau säugt Mann* (*Woman Nurses Man*), 1913. Charcoal, 8¼ × 8⅛ in. Sabarsky Foundation. Art © Estate of George Grosz/Licensed by VAGA, New York., NY.

Two of George Grosz's sketches in the exhibition, *Frau säugt Mann* (*Woman Nurses Man*) (Fig. 4, Chkl. 20) and *Anbetung* (*Adoration*) (Fig. 5, Chkl. 17) were created during his first year living in Berlin as a bohemian art student. By all accounts, Grosz was drawn to Berlin's rich and exotic night-life, and scholars who have consulted his correspondence from this period have shown that he was reading the work of Arthur Schopenhauer (1788–1860) and Friedrich Nietzsche (1844–1900), among other philosophers.[3] Certainly the satirical cynicism that characterizes so much of Grosz's work

cannot be fully explained only by his familiarity with and attraction to the work of Nietzsche, but it is important to keep in mind that Grosz, Dix, and other artists working in this period identified with what Flavell has called Nietzsche's "cultural pessimism."[4]

Grosz's pen and ink drawing *Adoration* (1912), created in his first year in the German capital, must certainly derive in part from the artist's own experiences, and yet it also is quite clearly the result of a shockingly vivid imagination. Three naked women prostrate themselves on their elbows and knees before an erect bacchic herm with the face of a monstrous, salivating, syphilitic clown. Grosz rendered the setting for this sadomasochistic rendezvous using only the quickest strokes of pen and ink, but what we see

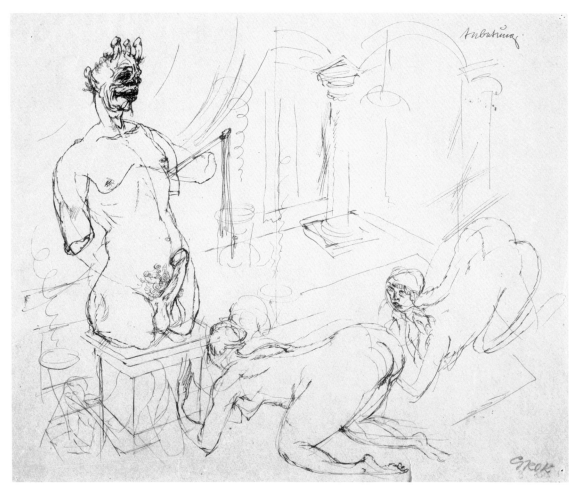

Fig. 5. George Grosz, *Anbetung* (*Adoration*), 1912. Pen and ink, 9 × 11⁵⁄₁₆ in. Sabarsky Foundation.
Art © Estate of George Grosz/Licensed by VAGA, New York, NY.

is a vaguely classical, temple-like interior complete with incense burning in stands surrounding the herm's pedestal.

Missing all four of his limbs, the body of Grosz's herm formally recalls Antique models such as the Farnese Hercules and the Belvedere Torso. Where other artists famously focused their attention on the musculature and strength of these Antique figures, this herm is full of puzzling contradictions; as Grosz did in so much of his work, this image is both in conversation with the Western canon and yet satirizes it at the same time. Both dead and alive, the herm is fully erect yet totally immobile. With his fragmented arm he clutches a whip to his left side, which visually echoes both his erect penis and the phallic protrusions at the top and sides of his head. I would propose that this drawing can be read as a reflection of sorts on heterosexual male desire, for, despite its physical immobility and the visible signs of venereal disease, Grosz's herm dominates this scene and holds the naked women beneath him fully in his thrall.

If *Adoration* is a visual meditation on virility and the power of the phallus, *Woman Nurses Man*, a charcoal sketch from 1913, presents us with a dominant and voluptuous female figure nursing an adult man. Much as Grosz sent up the Western canon in the figure of the herm in *Adoration*, here he looked back to the visual tradition of *Caritas Romana* (Roman Charity), in which Baroque, Rococo, and Romantic artists used historicizing iconography to represent the classical story of a woman whose father was left to starve in prison, moving her secretly to nurse him from her own breast.[5] As Robert Rosenblum explained in his short analysis of this imagery, classical and medieval interpretations of Roman Charity present the story as an example of "filial piety," but Grosz turns this iconography into something expressly and perversely sexual.[6]

The two figures in this image hover at the center of the sheet of paper onto which they were hastily drawn. As Grosz would do in so many of his later satirical works, we see every bit of Charity's nude body, and yet if one looks closely one sees that she is also clothed. Indeed, she wears heeled shoes and the fabric of her dress seems to quiver at the edges of the hard lines that define parts of her actual body. As Charity kneels and holds her male companion to her left breast, he grips her around the waist with his right arm and he wraps his legs around her thighs. We can see through his clothing, and yet the only parts of his body that are visible with any clarity are his

erect penis and the eager and infantile expression on his face as he leans in to nurse. In this image, as in *Adoration*, I would suggest that, in addition to recording the variety of erotic opportunities available in Germany's bustling capital city in the years leading up to the war, these two images also place certain hallowed models of the western tradition in a range of precarious contemporary contexts. Did Grosz use these classical models to elevate the status of these scenes? Or did he integrate classical models into his satirical erotic vignettes as a way of commenting on the fate and status of the classical tradition? Or, as Manet's *Olympia* did nearly fifty years prior to the creation of these drawings, was Grosz interested in exposing the hypocrisies inherent in the tradition of the nude?

Created on the eve of the First World War, the two erotic sketches by George Grosz discussed above are in the most general terms responses to the libertinism of Berlin's nightlife, which we know he participated in fully.[7] Otto Dix's lithographs from the 1920s offer a different view of the nude female body, and the body of the prostitute in particular. Two of Otto Dix's lithographs in the catalogue, *Weiblicher Halbakt* (*Female Semi-Nude*) (Fig. 6, Chkl. 14) and *Louis und Vohse* (*Louis and Vohse*) (Fig. 7, Chkl. 13), were made in 1923, shortly after his move from Dresden to Düsseldorf. Each image presents us with a slightly different view of prostitution: in *Louis and Vohse*, Louis blocks the viewer's access to Vohse, who is stretched out on the divan in the background; in *Female Semi-Nude*, the subject poses directly for the viewer/client and addresses him directly.

The figures in Dix's two images are willing participants in the exchange of money for sexual services. The anonymous nude woman who turns and smiles at the viewer in *Female Semi-Nude* bears on her aging body the marks of Germany's recent history. This nude is decidedly not erotic, even as she strikes a familiar pose of an academic Venus or Aphrodite. Like Grosz's Charity, she is playing a role for the viewer, and the appeal of this image derives from the contrast between her open and almost youthful expression and her stretch-marked and pendulous breasts; these features echo each other formally and vie for attention in the picture. As is the case with so much of Dix's artistic output, her body tells a story that is tied on the one hand to whatever her own personal history might be (clearly this is a body that has nurtured children), but on the other hand we are also to read her body as a metaphor for Germany's own precarious political and financial situation in the wake

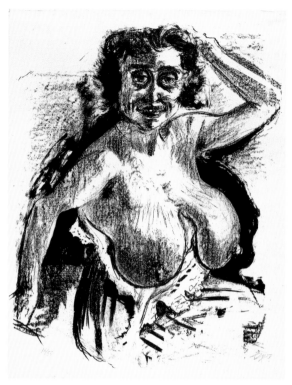

Fig. 6. Otto Dix, *Weiblicher Halbakt* (*Female Semi-Nude*), 1923. Lithograph, 23⅝ × 19⁵⁄₁₆ in. Sabarsky Foundation. © 2015 Artists Rights Society (ARS), New York/VG Bild-Kunst, Bonn.

of the First World War. That is, Dix was feminizing Germany's relationship to the rest of the world in this image, comparing it to a worn-out prostitute posing for her john and putting on a happy face.

By comparison, the figures in Dix's *Louis and Vohse* address the viewer with impassive predatory stares; they are sizing up a client, and we as viewers are placed in that role. Standing guard in the left foreground, Louis dangles a cigarette from the left corner of his mouth as he looks out from the picture plane. Dark circles surround his eyes, and his greasy hair appears stuck to the sides of his head. He sports a trim mustache that twenty-first-century viewers associate first with Adolf Hitler, but which, at the time of this image's creation in 1923, merely conformed to contemporary tastes. Dix added a series of dark marks along the edges of Louis's left shoulder, and these marks separate him from Vohse, who is stretched out on a chair in the background, unclothed except for ribbed stockings and shoes.

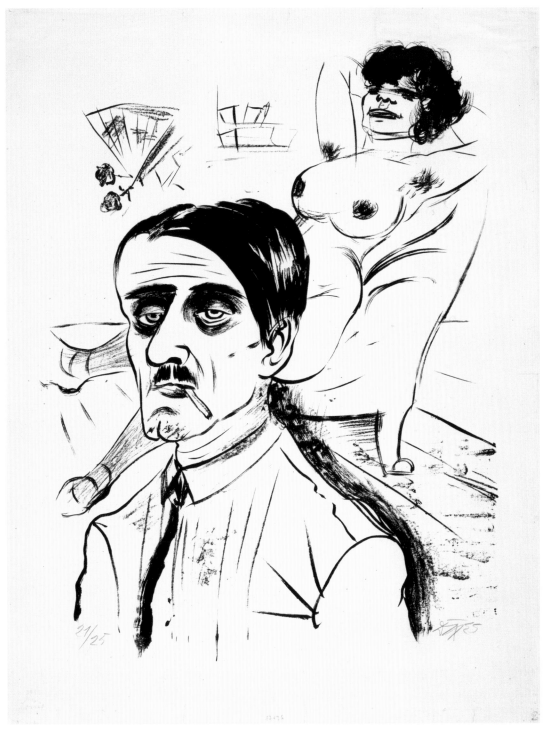

Fig. 7. Otto Dix, *Louis und Vohse* (*Louis and Vohse*), 1923. Lithograph, 25⁷⁄₁₆ × 19⁵⁄₈ in. Sabarsky Foundation. © 2015 Artists Rights Society (ARS), New York/VG Bild-Kunst, Bonn.

Like Dix's nude prostitute discussed above, Vohse also strikes a pose for the viewer that evokes academic tradition. Her arms are raised and placed behind her head in a pose that directly echoes Goya's *Nude Maja* from circa 1800. Goya's *Maja* reclines in the nude on a rich and comfortable green velvet divan covered with soft white pillows and sheets. In Dix's interpretation of Goya's pose, which carried with it an air of romantic familiarity, Vohse's body and her rehearsed posture read as an advertisement for her services. Indeed, even her lidded gaze suggests control that Louis, her pimp and guardian, reinforces.

As he did in his image of the aging nude prostitute discussed above, Dix organized this picture so that the eyes and breasts are aligned, and here both pairs of eyes bracket Vohse's breasts. This rather simple compositional tool allowed Dix to frame quite cleverly the breasts that are a principle subject of this image. I would argue that Vohse's breasts stand as a synecdoche for the kind of exchange we as viewers enter into with the subjects of the image.

Of course, what is most clear about this image is that Louis owns and controls access to Vohse's body, and this is the source of their livelihood and their dependence on one another. In *Louis and Vohse,* as in *Female Semi-Nude*, we see prostitution as the most basic of capitalist enterprises, and yet *Louis and Vohse* is suffused with a sinister air that is absent from *Female Semi-Nude*. It is Louis's figure and the impassive, unfeeling directness of his stare that unsettles this image. If we can say that the body of Dix's *Nude* is a metaphor for the Weimar Republic, we can perhaps also view Louis as an embodiment of capitalism itself.

In contrast to their peers in the artists' capitals of Paris and Rome, George Grosz and Otto Dix were not interested in abandoning the world of representation for that of abstraction, but their work was nonetheless grippingly experimental. Both Grosz and Dix were interested in creating imagery that was intellectually sophisticated and politically radical, and yet it was important to both artists for their work to address itself a wide variety of viewers. If Klimt and Schiele's graphic works isolate the body from any surroundings in the interest of drawing attention to its erotic capacities, Grosz and Dix, working in a representational idiom, as opposed to abstraction, expanded the symbolic resonances that the human body could take on.

NOTES

1. T. J. Clark, *The Painting of Modern Life: Paris in the Art of Manet and his Followers* (Princeton, NJ: Princeton University Press, 1984), 79–146. Clark begins this chapter by speaking specifically about prostitutes, but Manet's *Olympia*, the real focus of the chapter, was intended to specifically address and challenge the tradition of the nude.

2. See the work in Alessandra Comini, *Egon Schiele: Portraits* (Munich: Prestel, 2014); and in *Egon Schiele: The Radical Nude*, ed. Barnaby Wright, Peter Vergo, and Gemma Blackshaw (London: Paul Holberton, 2014).

3. M. Kay Flavell, *George Grosz: A Biography* (New Haven, CT: Yale University Press, 1988), *passim*. On Grosz and Communism, see Barbara McCloskey, *George Grosz and the Communist Party: Art and Radicalism in Crisis, 1918–1936* (Princeton, NJ: Princeton University Press, 1997).

4. Flavell, *George Grosz*, 191.

5. See Robert Rosenblum, "Caritas Romana after 1760: Some Romantic Lactations," in *Woman as Sex Object: Studies in Erotic Art, 1730–1970*, ed. Thomas B. Hess and Linda Nochlin (New York: Newsweek, 1972), 43–63.

6. Rosenblum, "Caritas Romana after 1760," 43. Rosenblum explains that, over the course of the eighteenth and nineteenth centuries, painters began to eroticize the incestuousness of the story.

7. Flavell, *George Grosz*, 42–46.

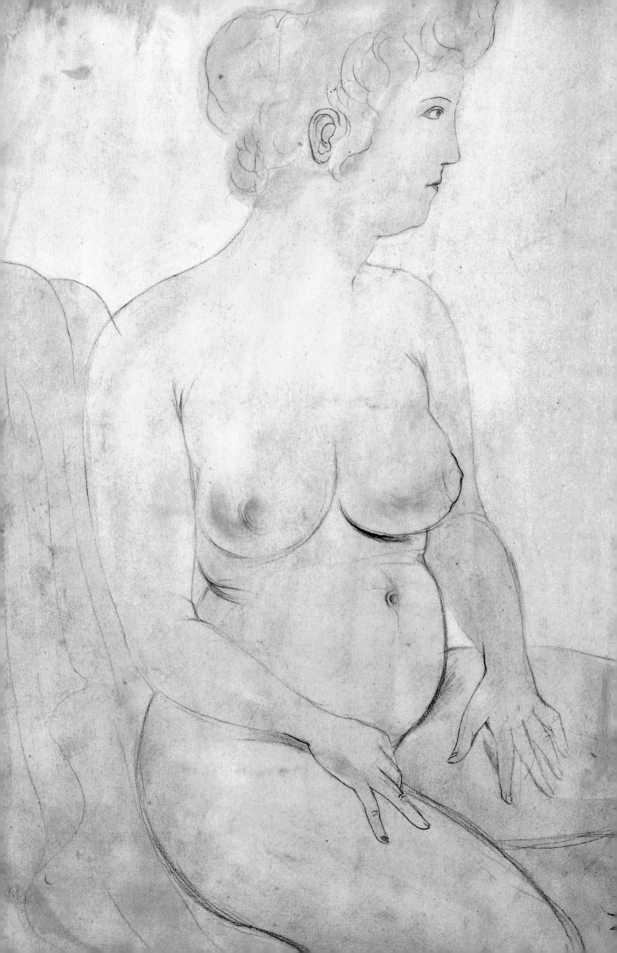

On the Grotesque Body in a Double-Sided Drawing by Otto Dix

James A. van Dyke

"Yesss, but there is also a desire in the grotesque, just as everything in the world is always dialectical! How the oppositions stand next to each other! Here is the solemn—and right next to it the comical!" [1]

THE YEAR 1924 was decisive in the career of Otto Dix, who was to become one of the most important German painters of the 1920s and 1930s—a man whose work is now central to any account of the New Objectivity in painting in particular, of Weimar Culture more broadly, and, most generally, of the history of modern critical realism. [2] Dix's career as a professional artist in Germany's post-war avant-garde began in Dresden in 1919, where he associated with a group of politically radicalized Expressionists. In the following years, he consorted with Berlin Dada and other cutting-edge circles, doing what the avant-garde artist was expected to do, making work that elicited private and public expressions of disgust and outrage. In 1922 and 1923, the German police and courts twice intervened against work—paintings of prostitutes—deemed to be obscene. In 1924, the tenth anniversary of the beginning of the First World War, Dix's monumental and horrifically gory painting *Trench* was exhibited in Berlin. That—and to an extent the release of his thematically related print portfolio *War*, which included *Sterbender Soldat (Dying Soldier)* (Chkl. 15)—prompted an acrimonious public debate that cemented Dix's national notoriety. [3]

Yet while some of Dix's work could be scandalous, there was no question by 1924 that a growing critical consensus had emerged about its technical promise and provocative power. It was promoted and marketed assiduously by the dealer Karl Nierendorf, and received regular attention and accolades from leading critics in Germany's most prominent journals of modern art, as well as from lesser-known writers in important regional newspapers. That year the first monograph on Dix appeared. [4] And just a few months after the

Fig. 1. Otto Dix, *Schadow gewidmet. Sitzender weibli-cher Akt* (*Dedicated to Schadow. Sitting female nude*), 1923. Watercolor and pencil, 22¹⁄₁₆ × 14⅞ in. Düsseldorf, Stiftung Museum Kunstpalast. Photo: Stiftung Museum Kunstpalast–Horst Kolberg–ARTOTHEK. © 2015 Artists Rights Society (ARS), New York/VG Bild-Kunst Bonn.

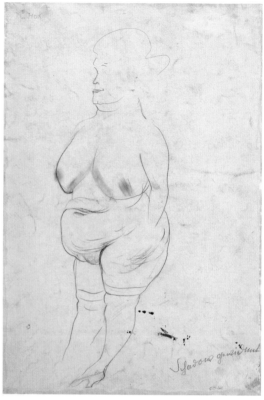

Fig. 2. Otto Dix, *Stehender weiblicher Akt* (*Standing female nude*), 1923. Pencil, 22¹⁄₁₆ × 14⅞ in. Düsseldorf, Stiftung Museum Kunstpalast. Photo: Stiftung Museum Kunstpalast–Horst Kolberg–ARTOTHEK. © 2015 Artists Rights Society (ARS), New York/VG Bild-Kunst Bonn.

controversy over *Trench* erupted in the summer of 1924, Dix exhibited forty recent watercolors at the National Gallery in Berlin, the most representative and prestigious museum in Germany. Among the many works included in that notable exhibition was a sheet known as *Schadow gewidmet* (*Dedicated to Schadow*) (Fig. 1), which Dix made in 1923.[5] It is now found in the Graphics Collection of the Museum Kunstpalast in Düsseldorf.

This watercolor, and the untitled drawing of a standing female nude on the other side of the sheet (Fig. 2) are the focus of this essay. These two pictures are not a part of the Sabarsky collection, of course, but nonetheless the physical object that they together constitute is certainly pertinent to thinking about the selection of pictures in *Naked Truth*. First, the watercolor and its companion drawing direct our attention to a material aspect of Dix's work

that has been overlooked by art historians, namely, his coordinated use of recto and verso to meaningful effect.[6] Second, the sheet is of particular value in this context because its two sides support two depictions of the female nude, which constituted a crucial theme both in Dix's oeuvre and in the work of modernist and avant-garde artists in Central Europe from the 1880s to the 1930s. Finally, the sheet leads one to consider the broader significance that such representations of the female body might have had in Weimar Germany's modern, increasingly photographic, mass media culture.

Materiality and the Grotesque in a Double-Sided Drawing

Otto Dix was a prolific producer of works on paper. Some of this production was specific to the post-war inflation and hyperinflation and concomitant booming market for contemporary art in Germany (1919–23). Under the conditions of rapidly devaluing currency and of buyers eager to snap up reasonably priced art as a speculative asset, it was important to produce things quickly and cheaply. The priority in that market—at least until the very end of the hyperinflation, when the market collapsed—was on relatively affordable things that could be transported in a suitcase by a traveling dealer-salesman or that could be reproduced and sold multiple times in order to maximize revenue. Hence, between 1920 and 1924, Dix dashed off hundreds of gouaches and watercolors, almost his entire total production in those media, and all of his prints and print portfolios, including the five in this show. Drawing, on the other hand, was a medium of great importance to Dix throughout his career. Over its course, he produced some 6,287 drawings and pastels, mostly on regular sheets of paper of various sizes but occasionally on whatever scraps he had at hand: the backs of envelopes, the covers and cardboard backs of pads of drawing paper, letters and bills that he had received in the mail.[7] A few were made as gifts, or were jotted down as amusing illustrations in private letters. Many were made as independent works for sale. A large number of drawings, such as *Geburt* (*Birth*) (1927; Chkl. 16), were preliminary studies for paintings that became necessary when Dix began to employ techniques that required careful planning before unforgiving glazes were spread across painstakingly prepared canvases or wooden panels. The largest number, ranging from fleeting sketches made in tiny sketchbooks to quite polished drawings on large sheets of paper, were

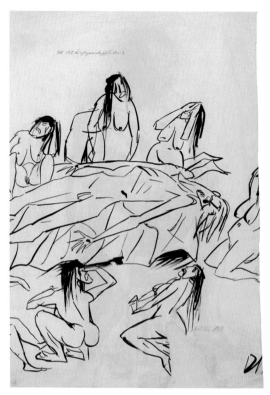

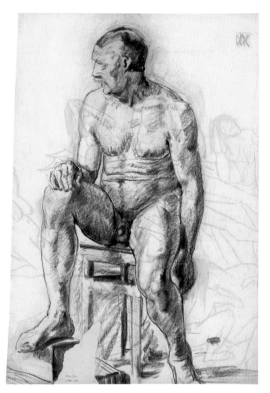

Fig. 3. Otto Dix, *Um einen Leichnam wehklagende Frauen* (*Lamenting Women around a Corpse*) ca. 1912–14. Pen and ink, 26⅝ × 18¹³⁄₁₆ in. Kupferstich-Kabinett, Staatliche Kunstsammlungen Dresden. Photo: Herbert Boswank. © 2015 Artists Rights Society (ARS), New York/VG Bild-Kunst Bonn.

Fig. 4. Otto Dix, *Männlicher sitzender Akt von vorn* (*Sitting male nude from the front*), 1912. Charcoal, 26⅝ × 18¹³⁄₁₆ in. Kupferstich-Kabinett, Staatliche Kunstsammlungen Dresden. Photo: Herbert Boswank. © 2015 Artists Rights Society (ARS), New York/VG Bild-Kunst Bonn.

exercises in observation and technique, and almost always focused on the human body.

The examination of important collections of Dix's drawings in Switzerland and Germany makes clear that Dix frequently used both sides of the sheet, though none of the objects in *Naked Truth* appear to be treated that way. Often, of course, and especially in Dix's years as a student before the First World War, this must have been a matter of economy; he could not afford to waste paper. However, in at least a number of cases this practice may have had not only a pragmatic but also a conceptual significance. In some of Dix's drawings, a form of argument by antithesis seems to be discernible in his use of recto and verso. Three examples will suffice to substantiate this claim here. Between 1912 and 1914, the years when he was engaging intensively with the art of French Post-Impressionism and more recent avant-gardes,

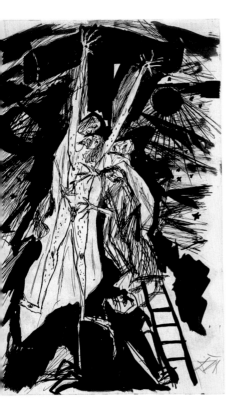

Fig. 5. Otto Dix, *Kreuzabnahme I (Descent from the Cross I)*, ca. 1914. Pen and ink, 7³/₁₆ × 10¹⁵/₁₆ in. Galerie Albstadt, Städtische Kunstsammlungen. Courtesy of Galerie Albstadt. © 2015 Artists Rights Society (ARS), New York/ VG Bild-Kunst Bonn.

Fig. 6. Otto Dix, *Ohne Titel (Mythologische Verfolgungsszene)* (*Untitled* [*Mythological Chase Scene*]), ca. 1914. Brush and ink, 10¹⁵/₁₆ × 7³/₁₆ in. Galerie Albstadt, Städtische Kunstsammlungen. Courtesy of Galerie Albstadt. © 2015 Artists Rights Society (ARS), New York/VG Bild-Kunst Bonn.

the twenty-one-year-old student of decorative painting opposed in a kind of stylistic *paragone* an academic male nude to a scene of seven women wailing over Christ's corpse, which amalgamates Matthias Grünewald in its stiffly extended limbs, Hans Holbein in the horizontality of the figure, Max Klinger in its nudity, and the artists of Die Brücke in its expressively crude, flattened yet energetic linearity (Figs. 3, 4). A second sheet from about the same time conjoins a spidery ink drawing of Christ, splayed and scourged in such a way as to recall the painting of Grünewald, being lowered from the cross, with a powerfully drawn image made with brush and ink that shows two or three nymphs being chased by a sexually aroused faun-like satyr (Figs. 5, 6). By means of this stylistic difference and perhaps by the ninety-degree rotation of the sheet, Dix, who by that time was immersed in Friedrich Nietzsche's critique of Judeo-Christian asceticism and contemporary society, graphically and materially emphasized the difference between self-denying Christianity and life-affirming Antiquity. Finally, in 1927 Dix made a two-sided drawing on the occasion of the birth of his second child and first son Ursus (Figs. 7, 8),

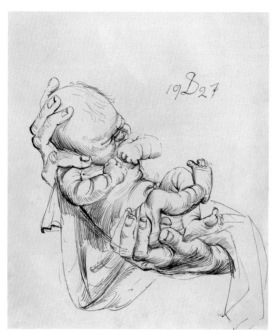

Fig. 7. Otto Dix, *Neugeborenes, von zwei Hän-den gehalten. Ursus* (*Newborn Child, Held in Two Hands. Ursus*), 1927. Pen and ink, 16¹¹⁄₁₆ × 14¼ in. Kupferstich-Kabinett, Staatliche Kunstsammlungen Dresden. Photo: Herbert Boswank. © 2015 Artists Rights Society (ARS), New York/VG Bild-Kunst Bonn.

Fig. 8. Otto Dix, *Selbstbildnis* (*Self-portrait*), 1927. Pen and ink, 16¹¹⁄₁₆ × 14¼ in. Kupferstich-Kabinett, Staatliche Kunstsammlungen Dresden. Photo: Herbert Boswank. © 2015 Artists Rights Society (ARS), New York/VG Bild-Kunst Bonn.

which is also recorded in a drawing in *Naked Truth* (Chkl. 16). On one side of the sheet, the viewer sees the infant cradled in two hands, presumably belonging to a midwife. Dix, who had in the meantime become an avid student of the old masters of the Northern Renaissance, appropriating their techniques, formats, and iconographies for his depictions of contemporary life, adapted Albrecht Dürer's praying hands of circa 1508, but replaced their disembodied symbolism of Christian piety with an image reverentially presenting the child's sexed body. On the verso, Dix drew a self-portrait that focuses on his pensive eyes, as though to underscore his distanced position as father, artist, and viewer, detached from the bodily process of childbirth, even if seemingly present in the room where it was occurring. At the same time, the two drawings, when viewed together, construe an identity between the artist and the creation of his reproductive powers. (It is certainly no coincidence that the monogram and date are inscribed above the drawing of the child, not the self-portrait.) When the sheet is held up to the light, one sees

that the painter's left eye aligns with the newborn's closed eyes. The child is body, the father vision.

A similarly coherent, antithetical interrelationship between the recto and verso of *Schadow gewidmet* (*Dedicated to Schadow*) is easy to see. On one side (the one that must have been treated as the recto in the exhibition of watercolors at the National Gallery in 1924) one sees the smoothly contoured and delicately colored figure of a softly curved young woman, sitting on a draped chair or sofa before a mild green background. Her pale pink skin is immaculate, her face is in profile, her manicured fingers rest gently on her thighs, and one hand hides her pubic area from the viewer's gaze. This adaptation of the *Venus pudica* type in Hellenistic sculpture is as chastely classicizing a figure as Dix had and would ever draw. The other side of the sheet of paper is very different technically, stylistically, and—to a certain extent—iconographically. The white ground of the surface on that side is smudged, and the broad washes of pink and green are replaced by a few splattered drips of concentrated blue and yellow pigment. Instead of smooth, thin contours, the figure is rendered with uneven and broken lines that produce the figure of a woman—neither whole nor only torso—wearing thigh-high stockings and a high-heeled pump on one tiny foot. The shapely curves and firm, pearly flesh of the first woman are replaced by a gray, dirty corpulence—cellulitic thighs, a bulging abdomen leading to pubic hair and a fold resembling labia, ponderous breasts, and a double chin—accentuated by the thickness of some of the lines and by smears of graphite. These two female nudes are generically related, but different in every particular respect. The effect of this double-sided drawing is far more pointed than the one produced by Georg Scholz's *Sitzender Akt mit Gipskopf* (*Sitting Nude with Plaster Head*) of 1927, which juxtaposes the copy of an Antique sculpture with an unblemished, stocking-wearing, fashionably coiffed New Woman (Fig. 9). It is unclear in the painting if differences are being accentuated, or likeness asserted.

This second woman on Dix's sheet is typical of much of his most distinctive work of the 1920s, as a glance at the selection of his prints and drawings in *Naked Truth* suggests. At the same time, his attention to the female body was by no means unusual in the masculine world of modernist and avant-garde artists. Like them, Dix tended to essentialize women physically and sexually, seeing them most frequently either simply as the raw material of

Fig. 9. Georg Scholz, *Weiblicher Akt mit Gipskopf* (*Female Nude with Plaster Head*), 1927. Oil on canvas, 25¹³⁄₁₆ × 21⅝ in. Staatliche Kunsthalle Karlsruhe. © 2015 Artists Rights Society (ARS), New York/VG Bild-Kunst Bonn.

art—as models, plain and simple—or as mothers, prostitutes, lovers, and muses.[8] Yet, the way Dix depicted women was distinctive. His figures rarely if ever look anything like Gustav Klimt's elegant Viennese nudes, which are weightless even when in the final stage of pregnancy. They do not resemble the nubile young women or pre-pubescent girls favored by Egon Schiele or Die Brücke artists Ernst Ludwig Kirchner, Max Pechstein, Erich Heckel, and Otto Mueller. Their contours go beyond the voluptuous female objects of desire typically depicted by Lovis Corinth and George Grosz, to whose work Dix's was and is often linked. It is certainly possible to point to emaciated boniness, sinuous litheness, and pert prettiness in Dix's hundreds or thousands of representations of women, but it is more usual to face enormous bulging guts, huge pendulous breasts, and vast pregnant bellies. He showed women giving birth and, for a few years in the early 1920s, depicted them occasionally as the victims of bloody evisceration. They are marked as frankly sexual and physically excessive, rather than discretely beautifully and fashionably enclosed bodies. Some are derived in part from the pages of pulp fiction and the tabloids.[9] Others—such as the tattooed Suleika (Chkl. 12) and the big-bosomed, cat-eyed lion tamer on display in *Naked Truth* (Chkl. 11)—belong to the popular world of the circus and the carnivalesque.

One key word that one frequently encounters when reading about Dix's Verism, and that is applicable both to *Schadow gewidmet* in particular and to most if not all the drawings in this exhibition's selection of his work in the Sabarsky collection, is "grotesque." Coined in the Renaissance to describe playful and fantastic ornament as well as images that were sinister or transgressed the rules of classical proportion and harmony, a number of German critics used the term in the early 1920s to characterize Dix's subject matter in particular.[10] Those who were appalled by the things that Dix made suggested that he was stuck in the mere appearances of a tawdry, vulgar, repulsive—grotesque—world, while his supporters asserted his ability either to critique them or to transform them into art.[11] More recently, art historians have discussed the bizarre, monstrous, ludicrous men and playful combination of materials in his Dadaist drawings and collages of the years 1920 and 1921 as prime examples of the grotesque in modern art.[12] This is certainly appropriate, but one can go further, keeping in mind Dix's own often-cited assertion late in his life of the dialectical relationship between the grotesque and desire.[13] Mikhail Bakhtin's descriptions of the carnivalesque—ribald, vulgar,

violent, bloody, rejuvenating—and of the grotesque—excessive, defecatory, sexual, visceral, procreative—and his assertion of their popular, realistic, and satirical nature bring to mind many of Dix's often exquisitely ugly, awfully fascinating, and outrageously provocative pictures from the entire decade, not just its first few years.[14]

The Grotesque Body, Academic Tradition, and the New Woman

In the Dix literature, *Dedicated to Schadow* is the title given to the water-color, because its style recalls the classicism of Johann Gottfried Schadow or of his son, Friedrich Wilhelm Schadow.[15] In 1788, the elder Schadow had been appointed a court sculptor in Prussia, becoming famous for his triumphant allegories (such as the Quadriga on the top of the Brandenburg Gate in Berlin) and his portraits of crown princesses and other members of the Prussian nobility (Fig. 10). It is even more likely, however, that Dix referred to the younger Schadow, who had been a member of the Nazarene movement in the 1810s and then, from 1826 until 1859, had served as the director of the Düsseldorf art academy, which under his leadership became one of the most important institutions in the German art world (Fig. 11).[16] One year before making *Dedicated to Schadow*, Dix had moved from Dresden to Düsseldorf, where he received instruction in printmaking in a master's class at the Düsseldorf academy and quickly established himself as a protagonist of the city's artistic culture until moving on to the even richer market and more important art scene of Berlin in 1925. However, Dix was associated with Düsseldorf's avant-garde—the Young Rhineland—and was receiving the acclaim of influential radical critics in Berlin such as Carl Einstein, who perceived in his work a vicious attack on the bankrupt cultural values of Germany's bourgeoisie.[17] Hence, it is difficult to imagine that Dix would have wished to pay homage to a consecrated artist so central to Prussia's academic artistic tradition by simple emulation. It is perhaps possible that Dix made such a picture in order to appeal speculatively to a particular kind of taste on the hyperinflationary art market, but it seems most likely that he meant to declare his difference from Schadow in a programmatic way.

Such a claim is supported by the axiomatic conflict between the academy and the avant-garde that still was being fought by Dix's friends and peers in Düsseldorf in 1923, though German art academies were soon to

Fig. 10. Johann Gottfried Schadow, *Doppelstandbild der Prinzessinnen Luise und Friederike von Preußen* (*The Crown Princesses Louise and Friederike of Prussia*), 1796–97. White marble, h: 67¾ in. Nationalgalerie, Staatliche Museen, Berlin, Germany. Photo: Erich Lessing/Art Resource, NY.

Fig. 11. Friedrich Wilhelm Schadow, *Agnes Rauch*, ca. 1825. Oil on canvas, 46⅝ × 34¼ in. Inv. 2517. Hamburger Kunsthalle, Hamburg, Germany. Photo: bpk, Berlin/Hamburger Kunsthalle/Hanne Moschkowitz/Art Resource, NY.

become much more open to the appointment of modernist professors than their French counterparts.[18] More particular evidence is provided by the double-sided drawing itself. First, the nude was very rare in the work of either Schadow and, furthermore, even in this, his most classicizing watercolor, Dix could not forego a hint of licentiousness. The woman does not just rest her hands on her thighs but rather seems to spread them, perhaps for some imagined viewer to the right. If so, the woman, despite her classicizing appearance, is not unlike the countless prostitutes rendered by Dix over the years. Second, there is the simple but hitherto overlooked fact that Dix inscribed the words "*Schadow gewidmet*" not on the recto (if we call the watercolor that), but rather on the verso, below and to the right of the drawing of the grotesque female figure, which is drawn with the same soft pencil.[19] To judge from this, Dix did not dedicate his vision of classical beauty to either Johann Gottfried or Friedrich Wilhelm Schadow. Instead, the watercolor seems to function as a pictorial antithesis or counterpoint to the crudely drawn figure on the verso. It was that second figure, which is nothing like the women depicted by either Schadow, that Dix dedicated to one of his canonical Prussian forebears—a mordantly ironic joke. Understood as two components of a single three-dimensional material object, like the obverse and reverse of a coin, the recto and verso of *Dedicated to Schadow* thus constitute an explicit statement not only of Dix's technical facility, but also, more importantly, of his critical realism, associated then and now with the term Verism. Dix's pointed parody of the artistic tradition of the Prussian state thus corresponds perfectly to Bakhtin's later, categorical opposition of grotesque realism and the "closed, smooth, and impenetrable surface of the body" in official classicism and naturalism.[20]

However, to leave it at that would ignore unjustifiaby the work of feminist art historians, who long ago showed that the sexual politics of the early-twentieth-century avant-gardes were anything but simply progressive or free of power dynamics.[21] Dix's drawings not only establish him as an artist opposed to the idealizations of academic tradition associated with state authority, they also articulate a limited image of women as mother or prostitute, model or muse. Only rarely did Dix engage with the often androgynous, gender-bending imagery of the New Woman of the 1920s. When he did, the results—with the exception of portraits of his wife, Martha, with a fashionable *Bubikopf* (pageboy) haircut—were typically not pretty (Fig. 12). His

Fig. 12. Otto Dix, *Bildnis der Journalistin Sylvia von Harden (Portrait of the Journalist Sylvia von Harden)*, 1926. Oil and tempera on wood, 47⅜ × 35¹⁄₁₆ in. AM3899P. Musee National d'Art Moderne, Centre Georges Pompidou, Paris, France. Photo: CNAC/MNAM/Dist. RMN-Grand Palais/Art Resource, NY. © 2015 Artists Rights Society (ARS), New York/VG Bild-Kunst Bonn. Photo: Jean-Claude Planchet

work, like that of the other leading painters of his generation, was absent from a well-known cosmetic company's contest to find the "Most Beautiful German Portrait of a Woman" in 1928, which was filled with depictions of variants of the New Woman type.[22] One might suggest that Dix's apparent antipathy towards such imagery and his focus on women's bodies that deviated from it was a form of resistance to standards disseminated by the German culture industry and its fashion system. That would relate it to his parody of the canonical artistic tradition exemplified by the Schadows. In the suppression of breasts, waists, hips, and long hair typical of the highly stylized image of the New Woman in 1920s fashion illustrations, cosmetics advertising, photojournalism, and film, one might see the construction of an ideal of feminine beauty not unrelated to the "closed, smooth, and impenetrable surface of the body" of traditional classicism.

Yet this line of argument would not take into account the prevalence of the voluptuous and highly eroticized female nude, verging on the pornographic, in Dix's earliest work as an artist, a fixation on a particular kind of female body long before the emergence of the New Woman in the 1920s. It also runs the risk of forgetting both the anxiety that the image of the New Woman provoked, and the real appeal that it had for many young German women during the Weimar Republic, who saw in it, as many scholars have pointed out, a means to articulate an identity that indicated their emancipation from the constraints of the past.[23] As feminist art historians such as Marsha Meskimmon have pointed out, Dix's work, like that of most of his male peers, had almost nothing to say about that historical reality, about the range of women's experiences in a rapidly changing German society not only as wives, mothers, and lovers, but also as workers, consumers, and citizens.[24] Hence, while there is no doubt that the grotesque realism of Dix's nudes did and still does possess a critical charge, challenging bloodless abstractions, such representations of the body, like most of the work in this exhibition, do not simply reveal the truth. They offer instead an imagery of gender and sexuality powerfully shaped and limited by the perspectives and pressures of male fantasy.

NOTES

1. "Jaa, das ist doch auch eine Lust am Grotesken, wie immer alles auf der Welt dialektisch ist! Wie die Gegensätze nebeneinander stehen! Hier ist das Feierliche—und gleich daneben das Komische!" "Otto Dix im Gespräch mit Maria Wetzel," *Diplomatischer Kurier* (Köln), no. 18 (1965), 731–45, quoted in Ulrike Lorenz, "Maler ohne Muse? Anmerkungen zu Leben und Werk von Otto Dix," in *Otto Dix: retrospektiv. Zum 120. Geburtstag. Gemälde und Arbeiten auf Papier*, ed. Holger Peter Saupe, exh. cat. Kunstsammlung Gera-Orangerie (Gera: Kunstsammlung, 2011), 13 (my translation).

2. Alex Potts, *Experiments in Modern Realism: World Making, Politics and the Everyday in Postwar European and American Art* (New Haven, CT: Yale University Press, 2013), 27.

3. See, for instance, Andreas Strobl, *Otto Dix: Eine Malerkarriere der zwanziger Jahre* (Berlin: Reimer, 1996), and Dennis Crockett, *German Post-Expressionism: The Art of the Great Disorder, 1918–1924* (University Park, PA: Pennsylvania State University Press, 1999), 87–98.

4. Willi Wolfradt, *Otto Dix* (Leipzig: Klinkhardt and Biermann, 1924).

5. Three reviews of the show are: Willi Wolfradt, "Berliner Ausstellungen," *Der Cicerone* 16, no. 24 (1924): 1199–1201; Max Osborn, "Aus dem Kronprinzenpalais. Ury—Corinth—Dix," *Vossische Zeitung*, November 28, 1924; Curt Glaser, "Ausstellungen von Corinth, Dix und anderen," *Berliner Börsen-Courier*, December 4, 1924.

6. The only exception to this are commentaries on Dix's double-sided self-portrait of 1915, one side of which shows him as an imperial soldier with ashen pallor, the other as a fiery Nietzschean blonde beast. For a useful extended discussion of double-sided drawings in general, but which does not include any work by Dix, see James G. Harper, *Verso: The Flip Side of Master Drawings*, exh. cat. (Cambridge, MA: Harvard University Art Museums, 2001).

7. Ulrike Lorenz, *Otto Dix. Das Werkverzeichnis der Zeichnungen und Pastelle*, vol. 1 (Weimar: VDG, 2002), 25.

8. For a few examples of feminist critiques of Dix's work, aside from the specific literature on the representation of sex-murder, see Jung-Hee Kim, *Frauenbilder von Otto Dix: Wirklichkeit und Selbstbekenntnis* (Münster: Lit, 1994); Dorothy Rowe, "Desiring Berlin: Gender and Modernity in Weimar Germany," in *Visions of the 'Neue Frau': Women and the Visual Arts in Weimar Germany*, ed. Marsha Meskimmon and Shearer West (Aldershot: Scolar Press, 1995), 143–64; and Marsha Meskimmon, *We Weren't Modern Enough: Women Artists and the Limits of German Modernism* (Berkeley, CA: University of California Press, 1999).

9. Beth Irwin Lewis, "Lustmord: Inside the Windows of the Metropolis," in *Women in the Metropolis: Gender and Modernity in Weimar Culture*, ed. Katharina von Ankum (Berkeley, CA: University of California Press, 1997), 202–32.

10. On the grotesque in general, see Wolfgang Kayser, *The Grotesque in Art and Literature*, trans. Ulrich Weisstein (Bloomington, IN: Indiana University Press, 1963); and Frances S. Connelly, *The Grotesque in Western Art and Culture* (Cambridge: Cambridge University Press, 2012).

11. For one example of the former position, see Fritz Nemitz, "Dresdner Sezession Gruppe 1919," *Dresdner Neueste Nachrichten*, May 25, 1922. For examples of the latter view, see Ludwig Hilberseimer, "Bildende Kunst," *Sozialistische Monatshefte* 27, no. 12 (July 11, 1921): 630; W—r, "Otto Dix. Ausstellung bei I. B. Neumann in Berlin," *Düsseldorfer Nachrichten*, March 28, 1923; and Wolfradt, *Dix*, 15.

12. See Eva Karcher, *Eros und Tod im Werk von Otto Dix* (Münster: Lit, 1984) Frances S. Connelly, ed., *Modern Art and the Grotesque* (Cambridge: Cambridge University Press, 2003), 3; Lorenz, *Werkverzeichnis* 2:515; Hanne Bergius, "Dada grotesk," in *Grotesk! 130 Jahre Kunst der Frechheit*, ed. Pamela Kort (Munich: Prestel, 2003), 137–47, esp. 142.

13. "Otto Dix im Gespräch mit Maria Wetzel," as in note 1.

14. Mikhail Bakhtin, *Rabelais and His World*, trans. Hélène Iswolsky (Bloomington, IN: Indiana University Press, 1984), esp. 210–12, 229–30, 317–18.

15. Suse Pfäffle, *Otto Dix, Werkverzeichnis der Aquarelle und Gouachen* (Stuttgart: Verlag Gerd Hatje, 1991), 184. Pfäffle assumes that the reference is to the elder Schadow on the basis of stylistic resemblance: "Schadow's chief works are distinguished by the perfection of their classical forms. The watercolor [Dix's] shows this type of figure" (my translation).

16. On father and son, see *Johann Gottfried Schadow und die Kunst seiner Zeit*, ed. Bernhard Maaz, exh. cat. Kunsthalle Düsseldorf (Cologne: DuMont, 1994).

17. Carl Einstein, "Otto Dix," *Kunstblatt* 7, no. 3 (1923): 97–102, reprinted in English translation in *The Weimar Republic Sourcebook*, ed. Anton Kaes, Martin Jay, and Edward Dimendberg (Berkeley, CA: University of California Press, 1994), 490–91.

18. O.K. Werckmeister, "Professor Beckmann! Professor Dix! Professor Klee! Professor Matisse? Professor Masson? Professor Léger?: Warum gab es nur in der Weimarer Republik, nicht dagegen in der Dritten Republik Professoren für moderne Kunst?," in *Zwischen Deutscher Kunst und internationaler Modernität: Formen der Künstlerausbildung 1918 bis 1968*, ed. Wolfgang Ruppert and Christian Fuhrmeister (Weimar: VDG, 2007), 207–17.

19. Pfäffle neither notes the location of the inscription nor considers its significance. She does not discuss in any detail the drawing on the verso, which is published in Lorenz's catalogue raisonné of Dix's drawings and pastels. In other words, though they share the same sheet of paper, they are separated by medium in the literature.

20. Bakhtin, *Rabelais*, 315, 317.

21. Carol Duncan, "Virility and Domination in Early Twentieth-Century Vanguard Painting," reprinted in Carol Duncan, *The Aesthetics of Power: Essays in Critical Art History* (Cambridge: Cambridge University Press, 1993), 81–108.

22. Christian Schad, Gert Wollheim, Werner Peiner, and Lotte Laserstein were among the participants. The competition was won by Willy Jaeckel. See Susanne Meyer-Büser, *"Das Schönste Deutsche Frauenporträt": Tendenzen der Bildnismalerei in der Weimarer Republik* (Berlin: Reimer, 1994), and Meyer-Büser, *Bubikopf und Gretchenzopf: Die Frau der 20er Jahre*, exh. cat. Museum für Kunst und Gewerbe Hamburg (Heidelberg: Edition Braus, 1995).

23. See, for instance, Atina Grossmann, "Girlkultur or Thoroughly Rationalized Female: A New Woman in Weimar Germany?" in *Women in Culture and Politics: A Century of Change*, ed. Judith Friedlander, Blanche Wiesen Cook, Alice Kessler-Harris, and Carroll Smith-Rosenberg (Bloomington, IN: Indiana University Press, 1986), 62–80; Kristine von Soden and Maruta Schmidt, eds., *Neue Frauen: Die zwanziger Jahre* (Berlin: Elefanten Press, 1988); Patrice Petro, *Joyless Streets: Women and Melodramatic Representation in Weimar Germany* (Princeton, NJ: Princeton University Press, 1989); Katharina von Ankum, ed., *Women in the Metropolis: Gender and Modernity in Weimar Culture* (Berkeley, CA: University of California Press, 1997); Mila Ganeva, *Women in Weimar Fashion: Discourses and Displays in German Culture, 1918–1933* (Rochester, NY: Camden House, 2008).

24. See Meskimmon, *We Weren't Modern Enough*.

Checklist of the Exhibition and Artist Biographies

All the works in the exhibition are courtesy of the Serge Sabarsky Foundation.

Willi Baumeister (German, 1889–1955)
Born in Stuttgart, Baumeister completed an apprenticeship there from 1905–07 after which he served in the military until 1908. While still an apprentice, he began to study at the Königlich Württembergische Akademie (today known as the Stuttgart Art Academy), during which time he met Oskar Schlemmer, who became his lifelong friend. Baumeister was conscripted into the German army in 1914 and served for four years. Although in his first exhibition (1910) he exhibited figurative work inspired by Impressionism, his subsequent work became increasingly abstract and geometric. The 1920s were particularly productive years for him, as he exhibited jointly with Fernand Léger in the Berlin gallery Der Sturm (1922), showed work at the 1924 Erste Allgemeine Deutsche Kunstausstellung (First General German Art Exhibition), and was given an entire gallery at the Große Berliner Kunstausstellung (Great Berlin Art Exhibition) in 1927. That same year he accepted a teaching position at the Städtische Kunstgewerbeschule (Frankfurt School of Applied Arts, also known as the Städelschule), a position he chose to keep when offered a post at the Bauhaus in Dessau. But, in 1933 with the Nazis in power, Baumeister was dismissed from the school. Still permitted to paint and exhibit (an opportunity rescinded in 1941), Baumeister continued to grow and experiment. He created some of his most ambitious and visually compelling work after the Second World War as his inherently abstract work became steadily more colorful and unified.

1. *Sitzende Figur (Visieren, abstrakte Sitzfigur)* (*Seated Figure [Aiming, Abstract Seated Figure]*), 1921–22
Lithograph on paper
15⅜ × 10¹³⁄₁₆ inches
illustrated p. 42

Max Beckmann (German, 1884–1950)
Beckmann was born in Leipzig, where his father was a grain merchant. In 1900 he was admitted to the Großherzogliche Sächsische Kunstschule in Weimar. It was there that he learned to draw from both antique sculpture and live models. By 1906 he had moved to Berlin, where he exhibited paintings with the Berlin Secession. Beckmann volunteered to help in the German war effort during the First World War, and served as a medical orderly. After suffering a breakdown in 1915 he was discharged, but within two years had returned to painting. By the 1920s, by which time he had become a successful and much admired painter, he was identified with artists who espoused the Neue Sachlichkeit (New Objectivity). During these years his often-large figural compositions were marked by bold colors and a precarious angularity. From 1925 to 1933 he taught at the Kunstgewerbeschule (Academy of Applied Arts) of the Städelsches Kunstinstitut (Städel Art Institute) in Frankfurt, but was dismissed once the Nazis gained power. In 1937 after Hitler condemned modern art as degenerate, Beckmann fled to Amsterdam, where he remained until after the end of the Second World War. His last years were spent in the United States where he resumed teaching and was given a retrospective in 1948 at the City Art Museum, St. Louis.

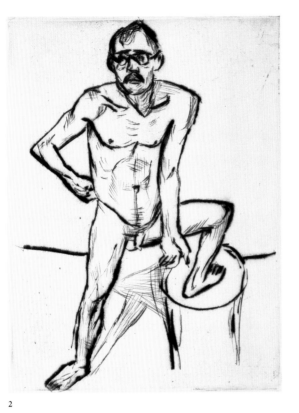

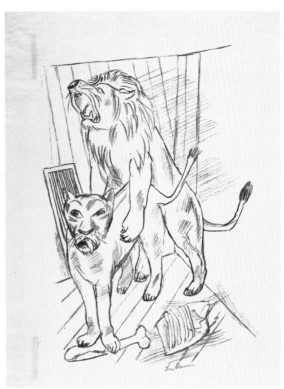

2

3

2. *Stehender männlicher Akt mit Brille*
 (Standing Male Nude with Glasses), 1919

Drypoint on paper
9⅜ × 7¹⁄₁₆ inches

© 2015 Artists Rights Society (ARS), New York/VG Bild-Kunst, Bonn

3. *Löwenpaar (Lion Couple)*, 1921

Lithograph on paper
20⁷⁄₁₆ × 15⅜ inches

© 2015 Artists Rights Society (ARS), New York/VG Bild-Kunst, Bonn

4. *Vor dem Auftritt (Akrobaten) (Before*
 the Performance [Acrobats]), 1923

Lithograph on paper
22⁷⁄₁₆ × 14³⁄₁₆ inches

illustrated p. 22

Lovis Corinth (German, 1858–1925)
Lovis Corinth was born in Tapiau in East
Prussia, the son of a tanner. In 1876 his family
moved to Königsberg, where Corinth began
his study of art with the genre painter Otto
Günther. On Günther's recommendation,
Corinth studied at the Academy of Arts in
Munich, followed by study at the Académie
Julian in Paris. Unable to achieve recognition
in France, the artist returned to Germany in
1887, where he became involved with the
Secession movement and eventually succeeded
Max Liebermann as the president of the Berlin
Secession in 1911. In the same year, however,
Corinth suffered from a stroke, which left him
partly paralyzed. Unhindered by this setback,
Corinth continued to produce many works
in a looser, more dynamic style that has often
been described as expressionistic, and it is in
this period following the stroke that Corinth
produced some of his strongest works. Though
best-known for his landscape paintings, in
particular of Lake Walchen in Bavaria, Corinth
also produced many works that dramatically
and often violently rendered religious or myth-
ological subject matter, of which *Judith schlägt
dem Holofernes das Haupt ab* (*Judith Beheads
Holofernes*) (1910) is a good example. Corinth
died in Amsterdam in 1925.

5. *Judith schlägt dem Holofernes das Haupt ab*
 (*Judith Beheads Holofernes*), 1910

Colored lithograph on paper
10⅝ × 9¼ inches

6. *Stehende weibliche Akte*
 (*Standing Female Nudes*), 1910

Etching on paper
13¼ × 20³⁄₁₆ inches

7. *Sündenfall* (*The Fall of Man*), 1911

Etching on paper
10¼ × 12¼ inches

8. *Liegender Frauenakt mit stehenden Modellen*
 (*Reclining Female Nude with Standing
 Models*), 1914

Lithograph on paper
20⅜ × 25⁹⁄₁₆ inches

9. *Susanna im Bade* (*Susannah in the Bath*), 1914

Etching on paper
7¹⁵⁄₁₆ × 5¹⁵⁄₁₆ inches

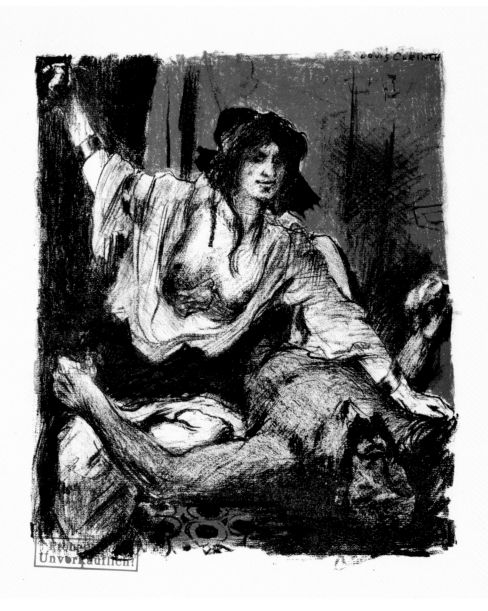

5

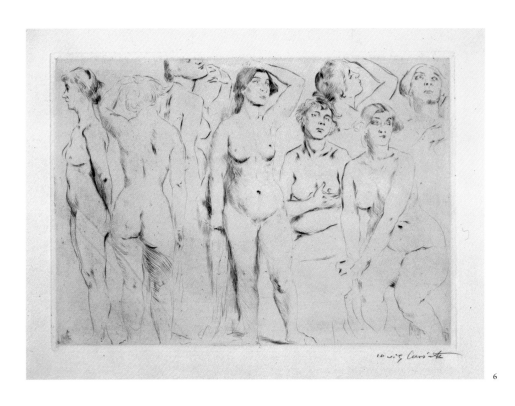

6

Probedruck Lovis Corinth

7

8

9

Otto Dix (German, 1891–1969)

Son of an iron foundry worker and a seamstress, Dix was born in Untermhaus, south of Leipzig. After serving a four-year apprenticeship with a painter, he entered the Kunstgewerbeschule (Academy of Applied Arts) in Dresden in 1910. Dix volunteered for the German army at the beginning of the First World War and served as a machine-gunner both on the Western front in France and the Eastern front in Russia, and suffered wounds before being discharged after hostilities ended in 1918. The imagery of war had a profound and lifelong impact on Dix and he was haunted by nightmares of combat. Dix's experiences led him to paint subjects such as that of *The Trench* (1923), which depicted decomposing bodies and the general depravity of war. The following year he published *Der Krieg*, a portfolio of fifty etchings, which addressed similar themes. Along with George Grosz, his friend and fellow war veteran, Dix became a leader in the movement called the Neue Sachlichkeit (New Objectivity). Its adherents were critical of the inequalities of post-war society, where wounded veterans begged in the streets while the wealthy ignored them and reveled in urban café nightlife. Although his work was condemned by the Nazis, Dix survived the Second World War and remained in Germany afterwards.

10. *Bewegung (Movement)*, 1920

Ink and pencil on paper
6¹⁵⁄₁₆ × 6⁵⁄₁₆ inches

11. *Dompteuse (Female Animal Tamer)*, 1922

Etching on paper
15¹¹⁄₁₆ × 11¹¹⁄₁₆ inches

10

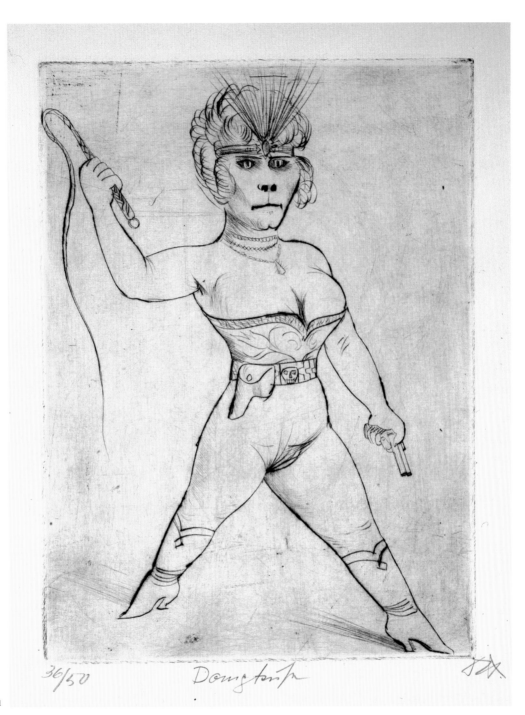

36/50 Dompteuse

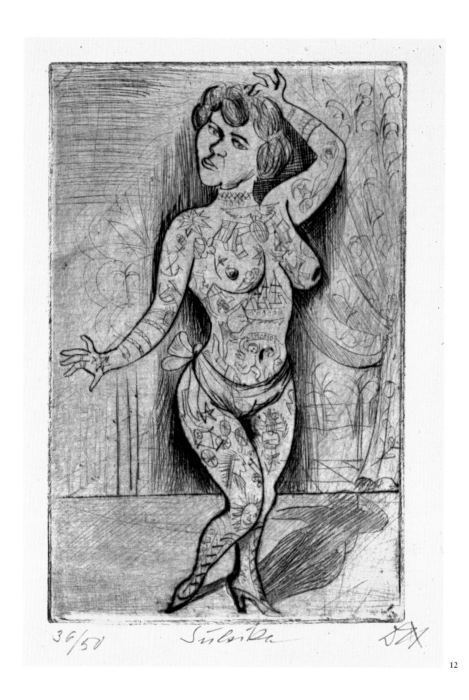

12

12. *Maud Arizona (Suleika, das tätowierte Wunder) (Maud Arizona [Suleika, The Tattooed Wonder]),* 1922

Etching on paper
19⅝ × 16¹⁵⁄₁₆ inches

13. *Louis und Vohse (Louis and Vohse),* 1923

Lithograph on paper
25⁷⁄₁₆ × 19⅝ inches

illustrated pp. 48, 57, cover

George Grosz (German, 1893–1959)

Grosz is perhaps best known today for biting caricatures disparaging German society in the years following the end of the First World War. Born in Berlin, the son of a pub owner, he studied at the Hochschule für Bildende Künste Dresden (Dresden Academy of Fine Arts), 1909–11, after which he left for Berlin. Like Otto Dix, Grosz volunteered for the German army in 1914, although he was hospitalized and discharged the following year. A prolific and gifted draughtsman with interest in a wide range of subjects, much of his artistic output in the postwar years were pen-and-ink drawings, often combined with watercolor, that depicted subjects such as corpulent businessmen and military officers or others who seemed to characterize the decadent life he observed in Germany after the war. In 1918 Grosz joined

the Communist party and was a staunch opponent of the Nazis as they gained influence. In 1933 he emigrated to the United States and taught at the Art Students League in New York until 1955.

17. *Anbetung (Adoration)*, 1912

Pen and ink on paper
9 × 11⁵⁄₁₆ inches

illustrated p. 53

18. *Illustration für "Ade, Witboi": Intimes Souper (Illustration for "Ade, Witboi": Intimate Supper)*, 1912

Crayon on paper
7⅜ × 9⁵⁄₁₆ inches

Art © Estate of George Grosz/Licensed by VAGA, New York, NY

19. *Jungenakt (Nude Boy)*, 1912

Pen and ink on paper
11⁵⁄₁₆ × 9 inches

Art © Estate of George Grosz/Licensed by VAGA, New York, NY

19

20. *Frau säugt Mann* (*Woman Nurses Man*),
　　1913

Charcoal on paper
8¼ × 8⅛ inches

illustrated p. 52

21. *Frauenakt, von hinten*
　　(*Female Nude, Back View*), 1915

Crayon on paper
9¹⁄₁₆ × 1 1⅝ inches

22. *Schlachtfeld* (*Battlefield*), 1915

Lithograph on paper
1 2³⁄₁₆ × 9½ inches

illustrated p. 24

23

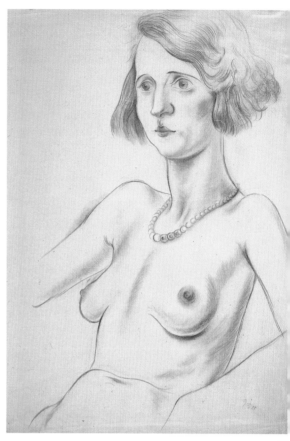

24

23. *Sitzender Frauenakt, von hinten (Seated Female Nude, Back View)*, 1927

Brush and India ink on paper
19¾ × 12¹⁵⁄₁₆ inches

24. *Modell mit Halskette (Fräulein Krumholz) (Model with Necklace [Fräulein Krumholz])*, 1928

Pencil on paper
28⅜ × 19½ inches

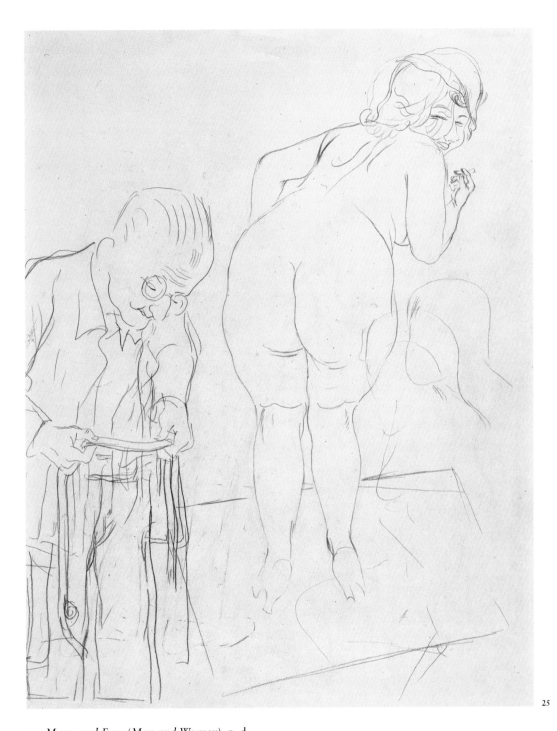

25. *Mann und Frau (Man and Women)*, n. d.

Pencil on paper

$23^{11}/_{16} \times 18^{1}/_{8}$ inches

Erich Heckel (German, 1883–1970)

A painter and prolific printmaker, Heckel was also one of the four founding members of Die Brücke (The Bridge), a group formed in Dresden in 1905 by artists who used high-keyed color, bold drawing, flatness, and distorted forms as well as intense unnatural colors to trigger in the viewer a profound emotional response. Heckel was the son of a railway engineer and was born in Döbeln, Saxony. After attending the Realgymnasium (secondary school) in Chemnitz he studied architecture at Dresden's Technische Hochschule (Technical College). Heckel relocated to Berlin in 1911 and although classified unfit for military service during the First World War, he served as a volunteer with an ambulance unit in Belgium. Over the course of his artistic career he created over 1,200 prints, more than 400 of which were woodcuts. The Nazi government declared his work degenerate in 1937 and confiscated 729 of his works. Many of his woodblocks and plates were destroyed in an air raid. After the war Heckel taught at the State Academy of Fine Arts, Karlsruhe, until 1955.

26. *Drei Frauen am Wasser*
 (*Three Women near the Water*), 1923

Woodcut on paper
22¹³⁄₁₆ × 17⅜ inches

illustrated p. 18

Ferdinand Hodler (Swiss, 1853–1918)

The only Swiss artist in this exhibition, Ferdinand Hodler, the eldest of six children, was born in Bern. His early life was characterized by many deaths in his family. His father Johann died of tuberculosis when Ferdinand was only seven years old, his mother Margarete died in 1865, and by 1889 all of Hodler's siblings had fallen victim to the same disease that had killed his father. These experiences left the artist with an acute awareness of death's looming presence in life, which became an important force in Hodler's creative production. Hodler's career as an artist began when he moved to Geneva in 1871 and was eventually noticed by Barthélemy Menn, a teacher at the Geneva School of Drawing who became a mentor to Hodler. After spending years in financial difficulty, Hodler finally achieved success and prominence in 1891 with *The Night* (1889–90). The painting was rejected by the Beaux-Arts exhibition in Geneva, but was subsequently recognized by the prestigious Salon du Champs-de-Mars in Paris, which brought the artist international fame. Hodler had an exhibition in 1904 at the Vienna Secession, which led to further critical acclaim. Gustav Klimt and Hodler were mutual admirers, while Hodler was an important influence on younger artists such as Oskar Kokoschka. Hodler had a unique approach to symbolism, which he called parallelism, a system of highlighting repetitive elements, symmetry, and parallel structures to create a natural spatial order in the composition. Due to this meticulous approach to creating his paintings, Hodler frequently made sketches over a grid pattern—an important step in his creative process exemplified by the *Studie für weibliche Figur* in this exhibition. Today, Hodler is widely recognized as the first great Swiss modern painter.

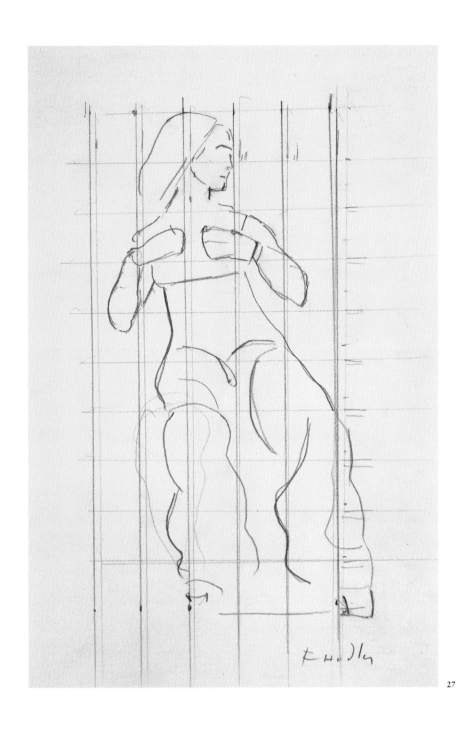

27. *Studie für weibliche Figur*
 (*Study for Female Figure*), n. d.

Pencil on paper
14¾ × 9¹³/₁₆ inches

Ernst Ludwig Kirchner (German, 1880–1938)
Kirchner was born in Aschaffenburg, the son of
a paper chemist. One of the founding members
of the artists group Die Brücke (The Bridge),
Kirchner made important contributions to the
style that became known as Expressionism.
Having completed his architecture degree at
the Königliche Technische Hochschule (Royal
Technical College) in Dresden in 1905, he
founded Die Brücke with fellow architecture
students Fritz Bleyl, Erich Heckel, and Karl
Schmidt-Rottluff. The group moved from
Dresden to Berlin in 1911, where the metropo-
lis and its nightlife became prominent motifs
in Kirchner's work. Die Brücke had several
successful exhibitions as a group, including
participation in the Sonderbund Ausstellung
(Special Union Exhibition) of 1912 in Cologne.
Some of Kirchner's finest works were created
after the group disbanded in 1913: a series
of *Straßenbilder* (street scenes), in which the
artist captured with his characteristic intense
colors and distorted proportions the psycho-
logical experience of modernity in the urban
environment. In 1915, Kirchner served as a
volunteer driver in an artillery regiment of the
German army, although he was discharged
after suffering a nervous breakdown. Kirchner
remained mentally unstable for the rest of his
life. After the Nazis came to power in 1933, his
art was declared degenerate and over 600 of his
works were confiscated. Dismayed by his own
declining health and the state of affairs in his
homeland, the artist took his own life in 1938.

28

28. *Badender Junge* (*Bathing Boy*), 1904

Woodcut on paper
7⅞ × 5½ inches

29. *Zwei Akte* (*Two Nudes*), 1908

Watercolor and gouache and colored crayon on paper
13¹⁄₁₆ × 17¹⁄₁₆ inches

30. *Nackte Frau am Fenster*
 (*Naked Woman near the Window*), 1912

Etching on paper
6¼ × 4⅝ inches

29

30

Gustav Klimt (Austrian, 1862–1918)
Klimt was born near Vienna, where he attended
the Kunstgewerbeschule (Academy of Applied
Arts) until 1883. His early success was based
on allegorical murals for a variety of public
buildings on the city's Ringstraße. In 1897 he
became one of the founding members of the
Vienna Secession, so named because the artists
involved broke away from the more traditional
historical style that then dominated much of
the arts in Austria. Klimt is best known for a
series of portraits he painted in the first years
after 1900, including *Adele Bloch-Bauer I*,
1907 (now in the collection of the Neue
Galerie, New York) in which his use of gold
leaf and decorative patterns produced remark-
able results. His premature death in 1918
resulted from the flu pandemic.

31. *Zwei Studien einer an einem Tisch sitzen-
 den jungen Frau, Wiederholung der rechten
 Schulterlinie (Two Studies of a Young
 Woman Seated at a Table, Repetition of the
 Right Shoulder)*, 1885

Pencil with white heightening on paper
13¾ × 12⅜ inches

illustrated p. 10

32. *Stehender Mädchenakt mit vorgebeugtem
 Körper nach links (Nude Girl Standing
 with Body Leaning Over, Facing Left)*,
 ca. 1900

Black chalk on paper
12¹⁄₁₆ × 16¹⁵⁄₁₆ inches

illustrated p. 50

33. *Mit angezogenen Schenkeln kauernder
Mädchenakt (Crouching Nude Girl with
Pulled-Up Thighs)*, 1903

Blue and red pencil on paper
12¹⁄₁₆ × 17⁹⁄₁₆ inches

illustrated pp. 33, 50

34. *Stehende nackte Schwangere nach links
 (Standing Pregnant Woman, Facing Left)*,
 1904–05

Black chalk on paper
17¹³⁄₁₆ × 12¹³⁄₁₆ inches

34

35. *Stehender weiblicher Rückenakt, die Arme horizontal gebeugt (Standing Female Nude, Back View, with Arms Horizontally Bent),* 1917–18

Pencil on paper
22⅜ × 14⅝ inches

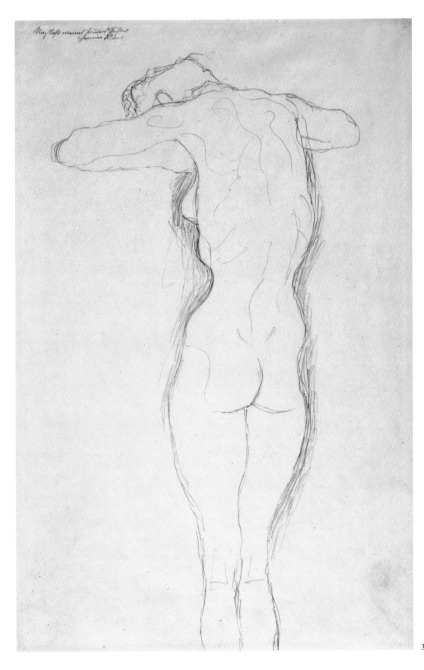

35

Oskar Kokoschka (Austrian, 1886–1980)
Born in Pöchlarn, Lower Austria, the son of
a Czech goldsmith, Kokoschka entered the
local Realschule (specialized secondary school)
where he had little interest in the curriculum
but excelled in art. As a consequence, in 1904
he applied and was admitted to Vienna's Kunst-
gewerbeschule (Academy of Applied Arts). In
contrast to the other artists in this exhibition,
Kokoschka worked not only in the visual but
also in the literary arts, producing significant
works such as the play *Mörder, Hoffnung der
Frauen* (*Murder, the Hope of Women*), which
influenced the development of Expressionist
drama, and the book *Die Träumenden Knaben*
(*The Dreaming Boys*), which was illustrated
with his lithographs. As for his productions in
the visual arts, Kokoschka's style was cha-
racterized by a "psychoanalytic" approach to
portraiture, in which he focused on physio-
gnomic idiosyncrasies of sitters to bring out
their inner character, frequently with disturbing
results. Kokoschka is also unique in that, unlike
his two fellow Austrians Klimt and Schiele, he
left the city of Vienna early on, disillusioned
by a conservative public that did not embrace
his innovations. Having left Vienna after the
end of the First World War (during which
he volunteered to serve in a cavalry unit but
was discharged after a heavy injury in 1916),
Kokoschka taught at the Kunstakademie (Aca-
demy of Arts) in Dresden from 1919 to 1924.
As a result, Kokoschka came to be associated
not only with the Wiener Moderne but also
with German Expressionism. Kokoschka spent
the rest of his life traveling from place to place,
only returning to Vienna on occasional short
visits. When the Nazis came to power and he
was labeled a "degenerate," Kokoschka fled
to London in 1938. After the war, Kokoschka
settled in Switzerland, where he stayed and
worked until his death in 1980.

36. *Liegender weiblicher Akt, von hinten
(Reclining Female Nude, Back View),
1912–13*

Pastel on paper
12⁵⁄₁₆ × 17¾ inches

© 2015 Fondation Oskar Kokoschka/Artists Rights Society (ARS),
New York/ProLitteris, Zürich

37. *Studie zu "Windsbraut"
(Study for "Windsbraut"), 1914*

Charcoal on paper
10¹¹⁄₁₆ × 17⅝ inches

© 2015 Fondation Oskar Kokoschka/Artists Rights Society (ARS),
New York/ProLitteris, Zürich

36

37

Käthe Kollwitz (German, 1867–1945)

The only female artist represented in this exhibition, Kollwitz was born Käthe Schmidt in Königsberg, Prussia. Starting in 1881 she received lessons from a local copper engraver and a painter, and in 1886 she moved to Berlin, where she attended the Künstlerinnenschule (School for Female Artists). She spent subsequent years studying in Königsberg and Munich, until she married the physician Karl Kollwitz and settled in Berlin in 1891. There, her husband attended to the needs of the poor and deprived, and the suffering of the downtrodden became an important theme in Kollwitz's work for the rest of her life. Meanwhile, Kollwitz continued to hone her artistry, spending a year in Paris studying sculpture at the Académie Julian and meeting Auguste Rodin. At the outbreak of the First World War in 1914, both of her sons volunteered to serve in the army; the younger of the two, Peter, died on the battlefield in October of the same year in Flanders, Belgium. This event had a profound impact on the artist, motivating her to create heart-wrenching images of motherhood and child death, as exemplified by the two prints in *Naked Truth*. In 1919 Kollwitz became the first woman ever to be awarded membership in the Prussian Academy of Arts, though she was later forced to resign when the Nazis came to power. Until her death in 1945, shortly before the end of the Second World War, Kollwitz remained an activist as well as an artist, confronting sociopolitical issues with her powerful realism.

38. *Hunger (Hunger)*, 1923

Woodcut on paper
8¹¹⁄₁₆ × 9 inches

illustrated p. 25

39. *Tod greift in Kinderschar
(Death Reaching for the Children)*, 1934

Lithograph on paper
19¹¹⁄₁₆ × 16⁹⁄₁₆ inches

39

Alfred Kubin (Austrian, 1877–1959)
Born in Leitmeritz, Bohemia, in the
Austro-Hungarian Empire (now Litoměřice,
Czech Republic), Kubin attended an arts and
crafts school in Salzburg, after which he was
apprenticed to a landscape photographer
(1892–96). In the last year of his apprenticeship
he attempted suicide. He briefly served in the
Austrian army, from which he was discharged
after a nervous breakdown. He enrolled in
the Munich Academy in 1899, but did not
complete his degree. Although he produced
paintings early in his career, over the years
most of his attention was devoted to other
media: pen and ink drawings, watercolors,
and lithographs. He exhibited with Der Blaue
Reiter (Blue Rider) in Munich in 1912, but in
subsequent years, as the result of the strong
influence of Odilon Redon and James Ensor, he
became preoccupied with dark, fantastical, and
sometimes morbid works loaded with symbol-
ism and often created in series. Over the course
of his career he illustrated more than seventy
books by Edgar Allan Poe, Oscar Wilde, E. T.
A. Hoffmann, Fyodor Dostoevsky, and others,
and produced illustrations for the German
fantasy magazine *Der Orchideengarten*. In
1904 he married, and two years later his wife
financed the purchase of a house in Zwickledt,
Upper Austria, where he lived until his death.
Despite being labeled by the Nazis as a creator
of degenerate art he survived the Second World
War in relative seclusion.

40. *Selbstmörderin (Female Suicide)*, 1922

Lithograph on paper
11 × 13⅜ inches

illustrated p. 39

Otto Mueller (German, 1874–1930)
Mueller was born in Liebau in what is now
Poland. In 1890 he entered an apprenticeship
as a lithographer, where his artistic talents
were first recognized. Mueller went on to study
at the Kunstakademie (Academy of Arts) in
Dresden, followed by study at the Academy of
Arts in Munich. In 1910, he came into contact
with the community of artists known as Die
Brücke in Berlin and soon became a member.
Together with other members of Die Brücke
such as Ernst Ludwig Kirchner and Erich
Heckel, Mueller spent time in the idyllic natural
landscapes of the Baltic Sea coast and Moritz-
burg wetlands near Dresden, exploring the
harmony between man and nature—a central
theme in his work. Another important aspect
of Mueller's oeuvre was his fascination with
Romani people, whose way of life he found
liberating. He taught at the Academy of Arts
in Breslau (today's Poland) from 1919 until his
death in 1930. Though he did not live to see it,
his works, like those of many of his contem-
poraries, were deemed degenerate by the Nazis
and more than 300 of his pieces were confisca-
ted from German museums in 1937.

41. *Knabe vor zwei stehenden und einem
 sitzenden Mädchen (Boy In Front of Two
 Standing and One Seated Girl)*, ca. 1919

Lithograph on paper
21⅝ × 17½ inches

illustrated p. 44

42. *Zwei sitzende Mädchen (II)*
 (*Two Seated Girls [II]*), 1921–22

Lithograph on paper
11⁷⁄₁₆ × 15¹¹⁄₁₆ inches

43. *Sitzendes und zwei liegende Mädchen im
 Gras (One Seated and Two Reclining Girls
 on Lawn)*, 1922–26

Lithograph on paper
12³⁄₈ × 17¹⁄₈ inches

illustrated p. 17

44

44. *Zwei stehende Mädchen*
 (*Two Standing Girls*), ca. 1928

Gouache and charcoal
26⅛ × 19³⁄₁₆ inches

Max Pechstein (German, 1881–1955)
Hermann Max Pechstein was born in Zwickau,
Saxony. Having started his artistic training as
an apprentice to a decorator, Pechstein went
on to study at the School of Applied Arts and
then at the Royal Art Academy in Dresden.
Erich Heckel invited him in 1906 to join the
artist group Die Brücke, which inspired him to
develop his own expressionistic style. Pech-
stein was fascinated by primitivism, going so
far as to travel to Palau in the Western Pacific
in 1914 to study and paint "exotic" subjects
there. *Kremios* (1917) in this exhibition is a
good example of this aspect of Pechstein's
work. The 1920s were a time of great success
for the artist, who enjoyed widespread public
recognition and took a teaching position at the
Berlin Academy in 1922. However with the
rise of Nazism, his art, too, was denounced as
degenerate and Pechstein was forced to resign
from the Berlin Academy, while more than 300
of his works were confiscated. He managed to
survive the war, however, and resumed teaching
at the Academy after 1945.

45. *Stehender weiblicher Akt
(Standing Female Nude)*, ca. 1910

Watercolor and gouache on paper
20½ × 15¹/₁₆ inches

46. *Kremios (Kremios)*, 1917

Woodcut on paper
9¹³/₁₆ × 7⅞ inches

47. *Das Vater Unser VIII—Und führe uns
nicht in Versuchung (The Lord's Prayer
VIII—And Lead Us Not into Temptation)*,
1921

Woodcut on paper
23⅜ × 16⁵/₁₆ inches

illustrated p. 20

48. *Am Strand (At the Beach)*, 1922

Etching on paper
14¾ × 11¾ inches

illustrated p. 45

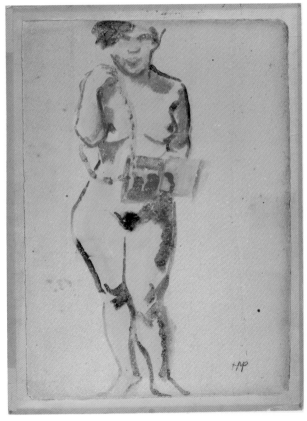

45

Egon Schiele (Austrian, 1890–1918)

Schiele was born in Tulln an der Donau, a few miles from Vienna, where his drawing skills were recognized at an early age. Like Klimt before him, Schiele entered the Kunst-gewerbeschule (School of Applied Art), where he stayed briefly before attending the Akademie der bildenden Künste (Academy of Fine Arts). When only sixteen Schiele was befriended by Klimt who arranged models for him and exchanged works with him. Beginning in 1908 Schiele began to exhibit his work regularly, although some found its explicitness shocking. By 1912 Schiele and Wally Neuzil, his model and lover, had moved to a small town outside Vienna. There the artist was arrested for seduction of an underage girl and, while this charge was dropped, he was subsequently imprisoned briefly for exhibiting his erotic drawings where they could be seen by children. In 1915 he married Edith Harms and shortly thereafter was conscripted into the army. Possessed of a weak heart, he avoided combat and as a consequence continued to be able to draw. By 1917 he was out of the army, back in Vienna, and exhibiting once again. In the fall of 1918, however, both he and his pregnant wife died in the flu pandemic.

49. *Stehender männlicher Akt, akademische Zeichnung (Standing Male Nude, Academic Drawing)*, 1907

Pencil and charcoal on paper
28 1/16 × 19 1/2 inches

illustrated p. 13

50. *Liebespaar (Lovers)*, 1913

Pencil on paper
18 7/8 × 12 5/8 inches

illustrated pp. 16, 51

Selected Bibliography

Apel, Dora. "'Heroes' and 'Whores': The Politics of Gender in Weimar Antiwar Imagery," *Art Bulletin* 79, no. 3 (1997): 366–84.

Bakhtin, Mikhail. *Rabelais and His World.* Trans. Hélène Iswolsky. Bloomington, IN: Indiana University Press, 1984.

Bergius, Hanne. "Dada grotesk," in *Grotesk! 130 Jahre Kunst der Frechheit.* Ed. Pamela Kort. Munich: Prestel, 2003.

Clark, T. J. *The Painting of Modern Life: Paris in the Art of Manet and His Followers.* New York: Knopf, 1985.

Comini, Alessandra. *Egon Schiele: Portraits.* Munich: Prestel, 2014.

Connelly, Frances S. *The Grotesque in Western Art and Culture.* Cambridge: Cambridge University Press, 2012.

Cowan, Michael and Kai Marcel Sicks, eds. *Leibhaftige Moderne: Körper in Kunst und Massenmedian 1918 bis 1933.* Bielefeld: Transcript Verlag, 2005.

Crockett, Dennis. *German Post-Expressionism: The Art of the Great Disorder, 1918–1924.* University Park, PA: Pennsylvania State University Press, 1999.

Duncan, Carol. "Virility and Domination in Early Twentieth-Century Vanguard Painting." In *The Aesthetics of Power: Essays in Critical Art History.* Cambridge: Cambridge University Press, 1993, 81–108.

———. *Egon Schiele: Nudes.* New York: Rizzoli, 1994.

Eberle, Matthias. *World War I and the Weimar Artists: Dix, Grosz, Beckmann, Schlemmer.* New Haven, CT: Yale University Press, 1985.

Egon Schiele: The Radical Nude. Ed. Peter Vergo, Barnaby Wright, Gemma Blackshaw, Kathryn Simpson. London: Paul Holberton, 2014.

Egon Schiele: The Ronald S. Lauder and Serge Sabarsky Collections. Ed. Renée Price. Munich: Prestel, 2005.

Flavell, M. Kay. *George Grosz, A Biography.* New Haven: Yale University Press, 1988.

Ganeva, Mila. *Women in Weimar Fashion: Discourses and Displays in German Culture, 1918–1933.* Rochester: Camden House, 2008.

Gay, Peter. *Weimar Culture: The Outsider as Insider.* New York: Harper and Row, 1968.

Grossmann, Atina. "Girlkultur or Thoroughly Rationalized Female: A New Woman in Weimar Germany?" in *Women in Culture and Politics: A Century of Change.* Ed. Judith Friedlander et al. Bloomington, IN: Indiana University Press, 1986.

Grosz, George. *George Grosz, An Autobiography.* New York: Macmillan, 1983.

Hess, Thomas B. and Linda Nochlin, eds. *Woman as Sex Object, Studies in Erotic Art, 1730–1970.* New York: Newsweek, 1972.

Hollein, Max and Tobias E. Natter, eds. *The Naked Truth. Klimt, Schiele Kokoschka and Other Scandals.* Munich: Prestel, 2006.

Karcher, Eva. *Eros und Tod im Werk von Otto Dix.* Münster: Lit, 1984.

Kim, Jung-Hee. *Frauenbilder von Otto Dix: Wirklichkeit und Selbstbekenntnis.* Münster: Lit, 1994.

Lewis, Beth Irwin. "Lustmord: Inside the Windows of the Metropolis." In *Women in the Metropolis: Gender and Modernity in Weimar Culture.* Ed. Katharina von Ankum. Berkeley, CA: University of California Press, 1997.

Lorenz, Ulrike. *Otto Dix. Das Werkverzeichnis der Zeichnungen und Pastelle*, Vol. 1. Weimar: VDG, 2002.

Meskimmon, Marsha. *We Weren't Modern Enough: Women Artists and the Limits of German Modernism.* Berkeley, CA: University of California Press, 1999.

Meyer-Büser, Susanne. *"Das Schönste Deutsche Frauenporträt": Tendenzen der Bildnismalerei in der Weimarer Republik.* Berlin: Reimer, 1994.

———. *Bubikopf und Gretchenzopf: Die Frau der 20er Jahre.* Heidelberg: Edition Braus, 1995.

Nickel, Patricia Mooney. "Public Intellectuality. Academics of Exhibition and the New Disciplinary Secession," *Theory and Event* 12, no. 4 (2009). http://muse.jhu.edu/journals/theory_and_event/vo12/12.4.nickel.html

Overhoff, Jürgen. "Nudismus: Im Lichtkleid zum Lebensglück," *ZEIT Online* 02/2013. http://www.zeit.de/zeit-geschichte/2013/02/freikoerperkultur-nudismus-lebensreform-kaiserreich

Petro, Patrice. *Joyless Streets: Women and Melodramatic Representation in Weimar Germany.* Princeton, NJ: Princeton University Press, 1989.

Pfister, Gertrud. "The Medical Discourse on Female Physical Culture in Germany in the 19th and Early 20th Centuries," *Journal of History* 17, no. 2 (1990): 183–98.

Pfäffle, Suse. *Otto Dix. Werkverzeichnis der Aquarelle und Gouachen.* Stuttgart: Verlag Gerd Hatje, 1991.

Reichert, Sven. "Gewalt. Körper. Politik. Paradoxien in der deutschen Zwischenkriegszeit," *Geschichte und Gesellschaft, Sonderheft* 21 (2005): 205–39.

Ruck, Nora. "Some Historical Dimensions of the 'Dialogical Body': From Bakhtin's Dialogical Grotesque Body to the Monological Body of Modernity," *Psychology and Society* 2, no. 1 (2009): 8–17.

Schade, Siegrid. "Der Mythos des 'Ganzen Körpers.' Das Fragmentarische in der Kunst des 20. Jahrhunderts als Dekonstruktion bürgerlicher Totalitätskonzepte," in *Frauen, Bilder, Männer, Mythen: Kunsthistorische Beiträge.* Ed. Ilsebill Barta. Berlin: 1987.

Schulze, Sabine. *Nackt! Frauenansichten. Malerabsichten. Aufbruch zur Moderne.* Ostfildern: Hatje Cantz Verlag, 2003.

Strobl, Andreas. *Otto Dix: Eine Malerkarriere der zwanziger Jahre.* Berlin: Reimer, 1996.

Toepfer, Karl. *Empire of Ecstasy, Nudity and Movement in German Body Culture, 1910–1935.* Berkeley, CA: University of California Press, 1997.

Toepfer, Karl, ed. "Sexual Experience and Body Culture. German Language Publications 1880-1932. Historical Sources of Women's Liberation Movement and Gender Issues, HQ 63." Harald Fischer Verlag, 2006. http://www.haraldfischerverlag.de/hfv/HQ/hq63_engl.php

Trachsel, Ronny. "Fitness und Körperkult. Entwicklungen des Körperbewusstseins im 20. Jahrhundert," in *Fitness. Schönheit kommt von außen.* Ed. Andreas Schwab and Ronny Trachsel. Bern: Palma-3 Verlag, 2003.

von Ankum, Katharina, ed. *Women in the Metropolis: Gender and Modernity in Weimar Culture.* Berkeley, CA: University of California Press, 1997.

Werckmeister, O. K. "Professor Beckmann! Professor Dix! Professor Klee! Professor Matisse? Professor Masson? Professor Léger?: Warum gab es nur in der Weimarer Republik, nicht dagegen in der Dritten Republik Professoren für moderne Kunst?" in *Zwischen Deutscher Kunst und internationaler Modernität: Formen der Künstlerausbildung 1918 bis 1968.* Ed. Wolfgang Ruppert and Christian Fuhrmeister. Weimar: VDG, 2007.